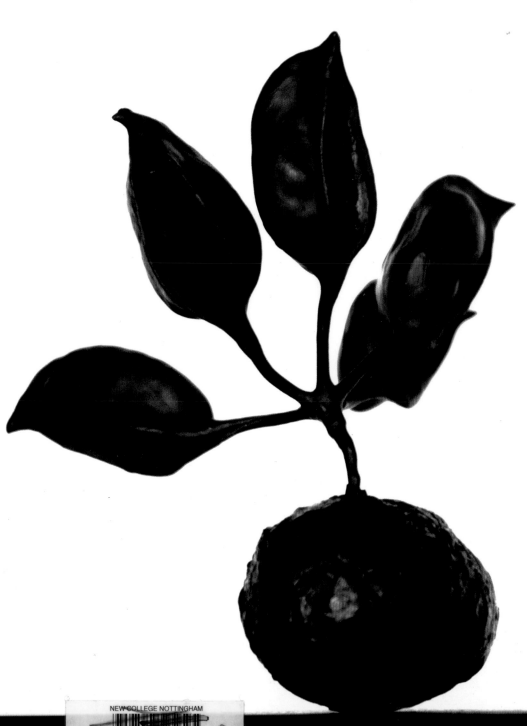

contents

& colophon

Contemporary Portraits of Fashion, Photography & Jewellery

Fashion

Clothes	Sadak	6
	Julius	10
	Jakub Polanka	14
	Txell Miras	18
	Songzio	22
	In Aisce	26
	Mr. Pearl	30
	Georgy Baratashvili	34
Shoes	Marloes ten Bhömer	38
	Alexander Fielden	42
	Nicholas Kirkwood	46
	Virtual Shoe Museum	50
Glasses	Oliver Goldsmith	54
	Christian Roth	58
Bags	Nico Uytterhaegen	62
	Assef Vaza	66
Hats	Noel Stewart	70
	Irene Bussemaker	74

Photography

Miss Aniela	80
Ken Merfeld	88
John Stoddart	96
Jamie Baldridge	104
Seb Janiak	112
James Chiang	120
Carla Verea	128

Jewellery

Michael Berger	138
Andrea Wagner	142
Marc Monzó	146
Mi-Mi Moscow	150
Carolina Vallejo	154
Jun Konishi	158
Philip Carrizzi	162

Noovo Editions is an independent editorial and cultural project by María del Rosario González y Santeiro and Jorge Margolles Garrote with online and paper editions. Noovo seeks to be an aesthetic arbiter and a cultural mediator at the juncture between Fashion, Photography and Jewellery: a platform to show the highest level of creativity from around the world.

www.noovoeditions.com

Noovo paper editions are published by
The Pepin Press BV
P.O. Box 10349
1001 EH Amsterdam, The Netherlands
mail@pepinpress.com

www.pepinpress.com

Noovo volume 1: Contemporary Portraits of Fashion, Photography & Jewellery
ISBN 978 90 5496 163 5

Fashion editor
María del Rosario González y Santeiro

Photography editor
Jorge Margolles Garrote

Publisher & editor in chief
Pepin van Roojen

Copy editor
Kevin Haworth

Special thanks to Michael James O´Brien and Dino Dinco

This book is produced by The Pepin Press in Amsterdam and Singapore. Printed and bound in Singapore.

This selection of international designers presents a diverse series of profiles that give us an insight into the work, thoughts and processes of some of the most celebrated practitioners in their fields.

Contemporary fashion, photography and jewellery are brought together in this special edition, and each discipline is represented by emerging talents and established practitioners. Each of them speaks to us in his or her own highly distinctive voice, but one theme unifies them all: a burning passion and commitment to their art.

With generosity and devotion, they give us a glimpse into their work and how it's created, or they simply throw a little light on their personalities, depending on their mood at the time of writing.

Contemporary Portraits of Fashion, Photography and Jewellery gives a unique and contemporary perspective on creative talent from around the world. The voices are contemporary yet timeless, reaching beyond established limits of beauty. As well they should, for beauty is surely about timelessness and reaching beyond the accepted. And because beauty is an expression of our own emotion.

fas
hi
on

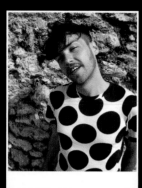

fashion designer

Sadak

http://www.sadak.de

For me, fashion is a way of communicating with and among people, so I combine social, historical and traditional elements with contemporary materials, playing with forms and meanings to create an authentic visual language. I embrace a system of signs and symbols that we use to positively indicate and differentiate between groups: class, occupation, gender and sexual affiliation.

The theme of my last collection, 'Lapot' was based on a Serbian tradition and tells the story of the custom of the killing of old people when they become incapacitated, or a burden to their family. The Serbian people named this 'Lapot'.

This solemn ritual would be announced in neighbouring villages. 'In this village, from this house there will be Lapot and the people are invited to wake'. Everyone in the house, including the old man or woman, would wear their best clothes. 'What was important was that the old man was not reluctant to die; on the contrary, he was ready to submit himself to the custom' (quote by S. Trojanovich.)

The whole concept is based on tradition, ethnography, anthropology, history and clothing. I incorporated elements from the past, with features from the period when the clothes were made and worn, often using the mystical and poetic stories.

Sadak is the ancient name for a traditional sleeveless jacket worn in regions of the Balkans. The preserved magical meaning of sadak is transformed and adapted to contemporary reality. It becomes independent through the development or construction of forms, figures, motifs, magical objects, statements, societal codes, space, objects and function.

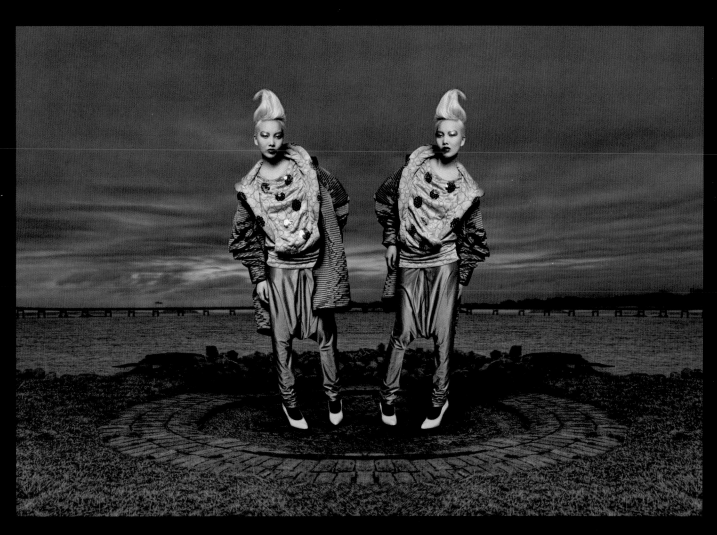

Sadak
Photograph: Daniel Bollinger

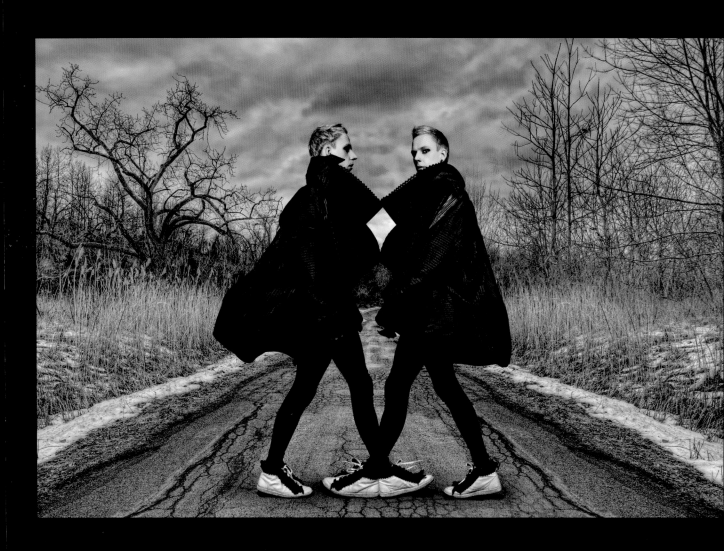

Sadak

Photographs: Daniel Bollinger
Make up: Kenny Cempbell
Models: Tobias Gärtner and Justin Kennedy
Styling: Sasa Kovacevic

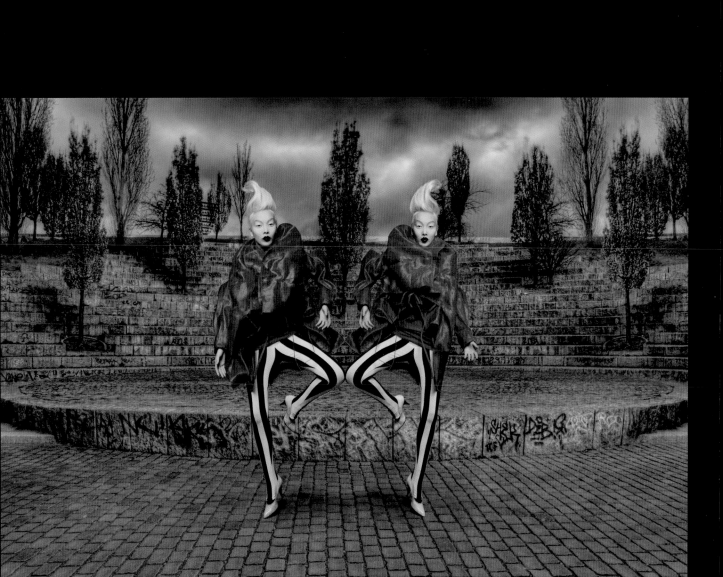

fashion designer

Julius

http://www.julius-garden.jp

There are many elements within me that contribute to the creation of a collection. I create the collection when all these accumulate to form one exceptional vision or idea. Elements such as art, architecture, music, ambient sound/noise, travel, emotional communication and my own internal creative urge.

The aim is not simply to create clothing, more to create and contribute to a total lifestyle and existence. The process is similar to making a movie. It's a sacred and profane thing. Sometimes the world of my imagination and vision becomes frayed and broken down, chaotic and corrupt; the stillness sunk beneath loud vibrational noise, like the purity and destruction within every pilgrim. It is a sharp and metallic industrial mayhem.

Black is always the base of my creative palette. BLACK symbolizes the avant-garde and has a spiritual and noble meaning for me. I am obsessed by the image of BLACK in Japanese religion, in Zen. It represents the crazy darkness hidden in the shadows, away from the light. It is the total colour of complete and utter grief.

– Tatsuro Horikawa (Julius)

10

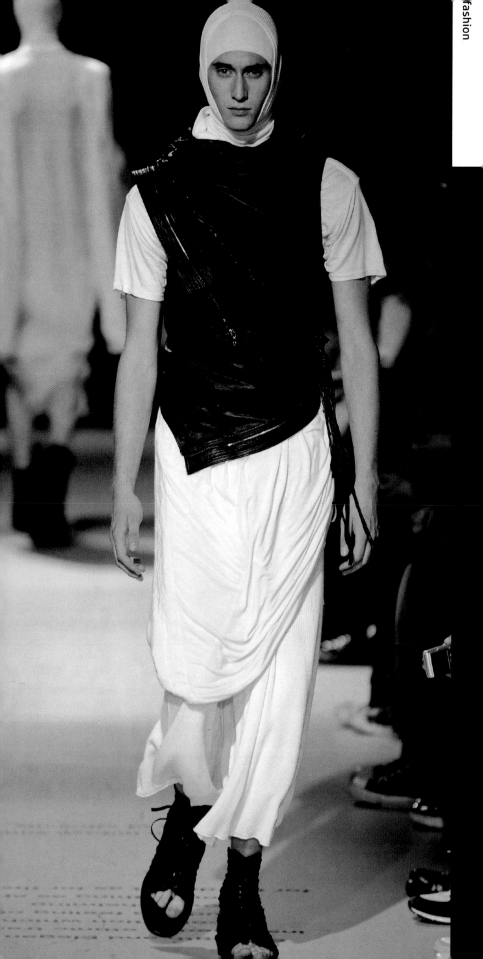

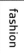
fashion

Julius SS1-3

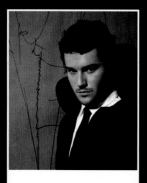

fashion designer

Jakub Polanka

http://www.jakubpolanka.com

I was born in a small forest village in the Czech Republic. The details of my professional life are on my website but here are a few details which I think are important: I love baked potatoes with cream cheese; I love creating collections but I hate selling them and, last but not least, I love to sing but I have no musical ear.

I decided I wanted to become a fashion designer when I was about three years old. I don't know why, and I probably wasn't sure what it meant. That's my earliest memory. It was also my first choice in high school.

I suppose I am influenced by everything that involves anatomy right now. It means I am trying to go beneath the surface of things, trying to create an organism and a system for how the garments are made. I am fascinated by how a piece of fabric can transform into something for the body without the use of scissors, or without interfering with its original geometric shape.

Jakub Polanka

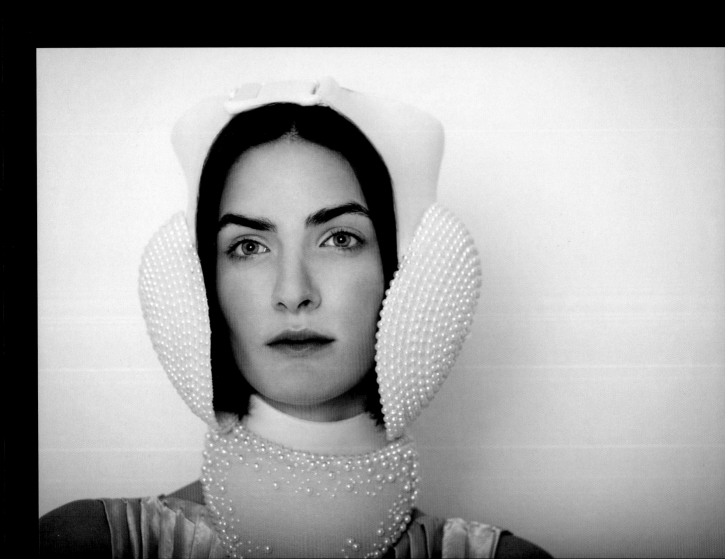

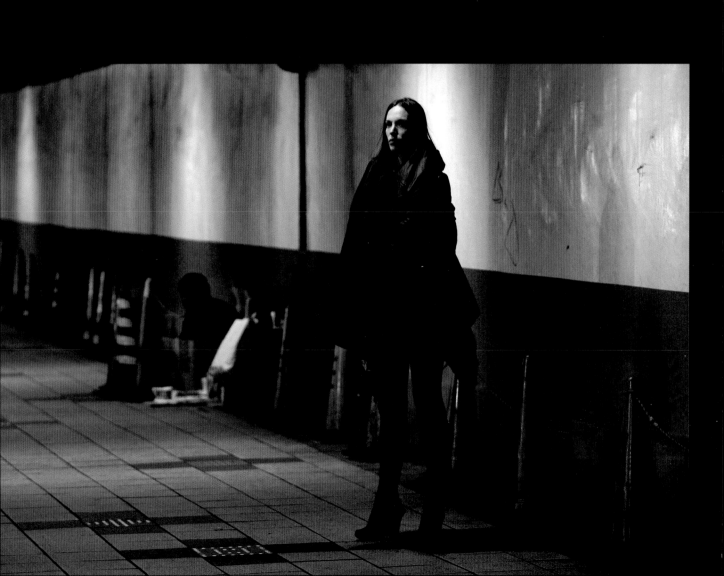

fashion designer

Txell Miras

http://www.txellmiras.eu

Human body, formal games and human mind. These are my obsessions when I design. When I start thinking about a new collection these three *leitmotifs* become naturally interrelated.

Be it the whole or the parts, each single fragment and detail will become a whole: the silhouette, the contour. Shapes that can be transformed into other shapes. The metamorphosis of a covered body. To construct a garment is to open the door for someone to build themselves. To dress is to speak out. To dress lets you be who you want to be.

My influences? Anything can affect me, or perhaps nothing. The ideas emerge from a copious inspirational magma. Bastard ideas from many fathers but no godfather. Orphan speeches with many mothers but no surname. Names such as Duchamp, Boltanski, Bergman, Dreyer, Faulkner, Kafka, and Gombrowicz, among many others, are already part of me. I also admire Kawakubo, Margiela and Westwood because they taught me that fashion can be more than fashion. They opened a path that I follow in my own way, with no mirrors and no complexes.

I feel that I have something to say. I need to say it and I do. With modesty and with arrogance but above all, with self-demand.

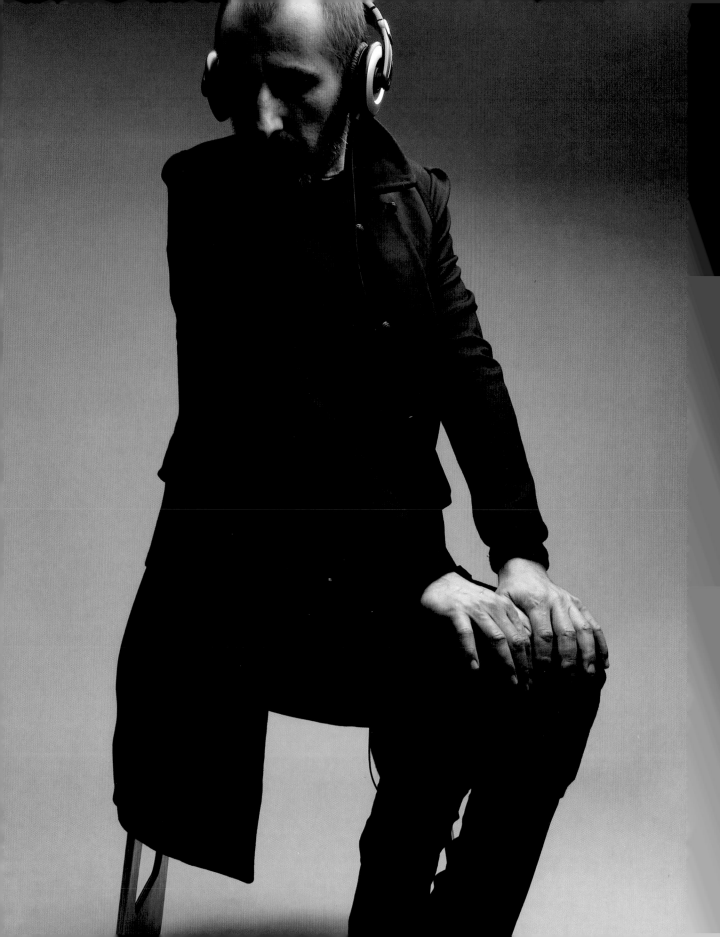

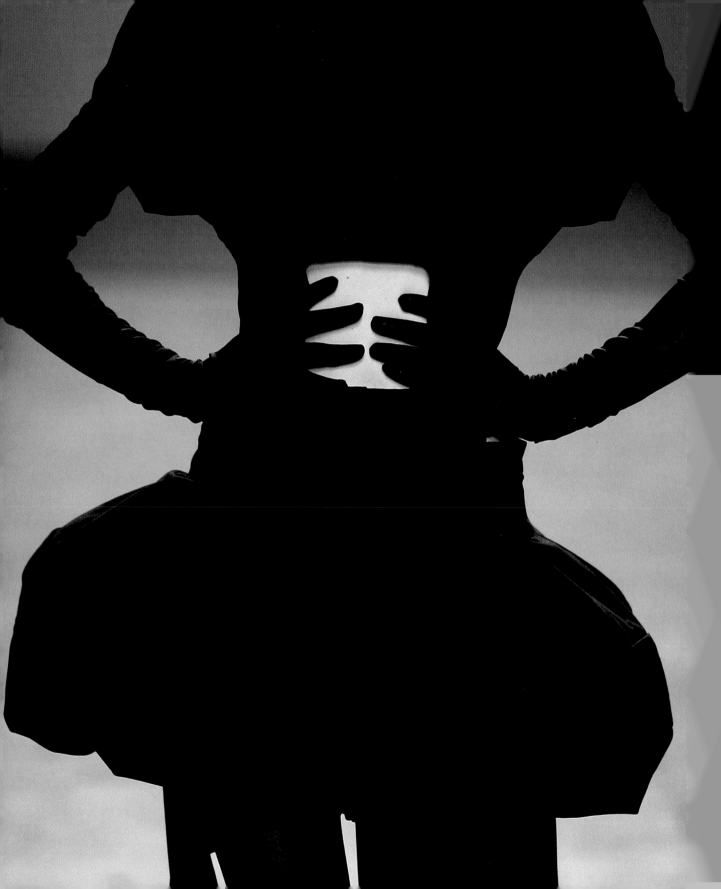

fashion designer

Songzio

http://www.songzio.com

Born in South Korea, Songzio graduated from ESMOD in 1987. He taught fashion in Seoul from 1989 to 2002 and launched his line for women in 1992. In 1999, he created his men's line and in 2007 presented his collection in Paris for the first time.

His fashion communicates dreams and aspirations: a means of understanding and incarnating the future. Songzio finds his inspiration in abundance, in refinement and in subtlety: in a dreamy world that carries images and sounds of boys longing for unknown lands.

For Songzio, men's fashion is free from the divisions between East and West. His creations are characterized by ambitious silhouettes and visually reflect the voyage a young man undertakes to achieve his dreams. This allusion, however, is overlaid with avant-garde architectural structures and his style surprises by its precision.

He unifies elements that represent youth's aspiration to bring a gleam of light into a dark world. Rock 'n' roll and military details represent the ambitious and archetypal spirit of the adolescent whose inspiration comes from the solitary battle to create a positive impact on the world.

Songzio creates contemporary casual clothing: a modern, sporty, dandy look for 21st century men. He uses high-quality Italian fabrics: stretch wool, stretch cotton, rayon and linen, but also synthetic fabrics, such as Gore-Tex.
He likes black and white. Furthermore, he uses what he terms 'modern colours' (cool grey, charcoal grey, melange grey), 'nautical colours' (navy and white), 'graphic colours' (shades of beige and brown), and 'strong graphic colour' (sky blue, Turkish red, pink, yellow, green).

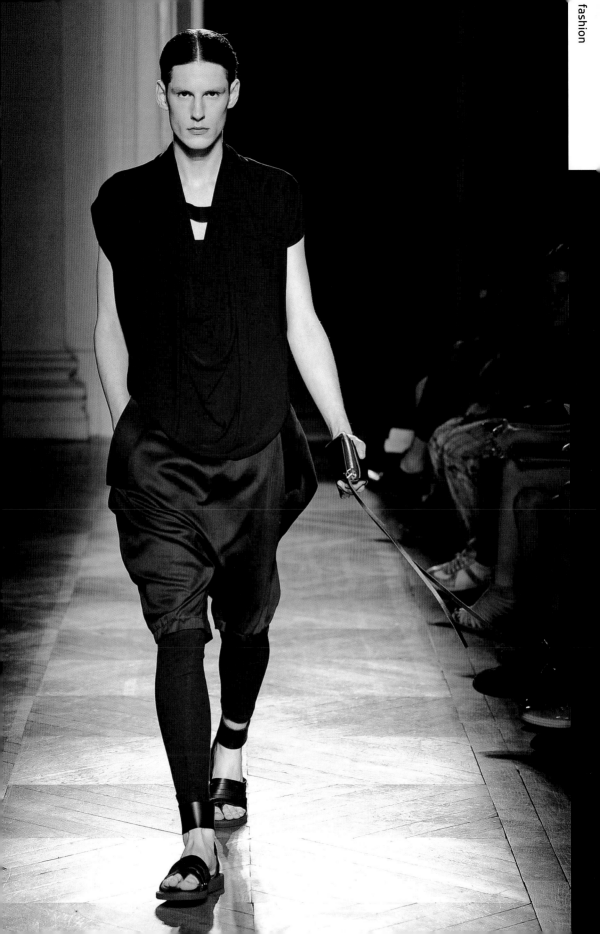

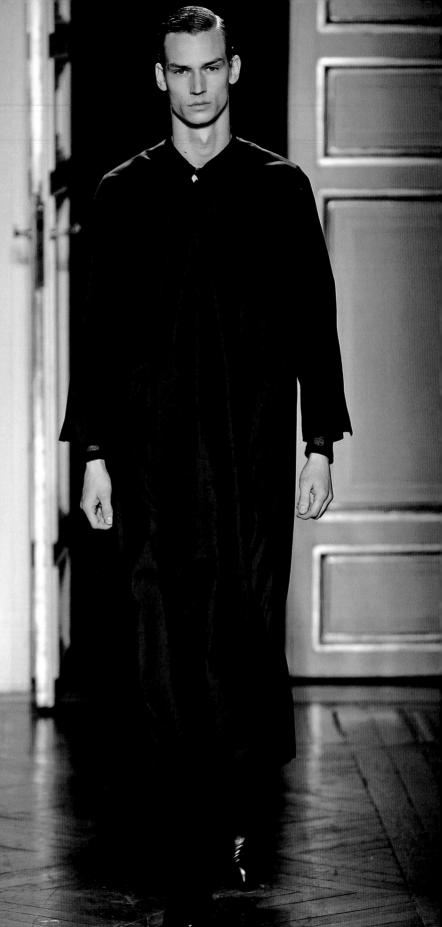

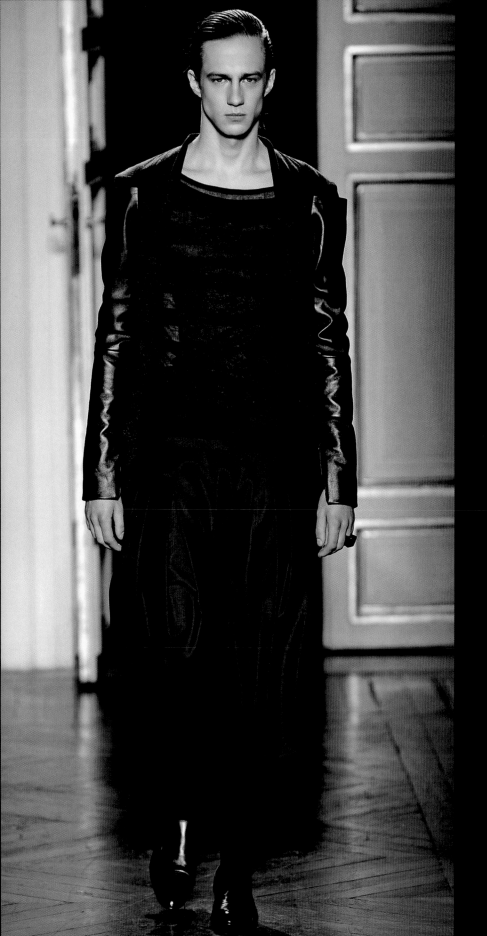

fashion designer

In Aisce

http://www.inaisce.com

In much of the so-called developed world, society is domi-nated by a throw-away lifestyle. Everything is made to be used for a short time and then tossed. Clothing is no excep-tion; the typical wardrobe is crammed with too much cloth-ing, most of it cheap and hardly worn. But some of us have been lucky enough to glimpse a different perspective. We select only what's necessary, and since that limits our oppor-tunities, we learn to choose carefully. We choose only that which will last, which is special in every element – longevity, comfort and, of course, beauty, qualities all too often ignored, particularly in the West.

I try to design each piece of each *In Aisce* collection as if it were the only jacket or the only pair of trousers in any particular wardrobe – and so it should perform, it should be strong, it should be stunning...

This approach may be grandiose and naïve, and my aim may be in vain, and I will be the first to say *In Aisce* is a work forever in progress. Even if one day I were to design near-perfect garments, they would still be purchased, worn, dis-carded, forgotten – every one of them. But it doesn't mean we stop making clothes, any more than a chef loses motiva-tion to make food, knowing that it will be excreted shortly after its ingestion.

I invite those interested to watch the evoluti
I attempt to make pieces that speak for them
tions that are bonded by an extraordinary, y

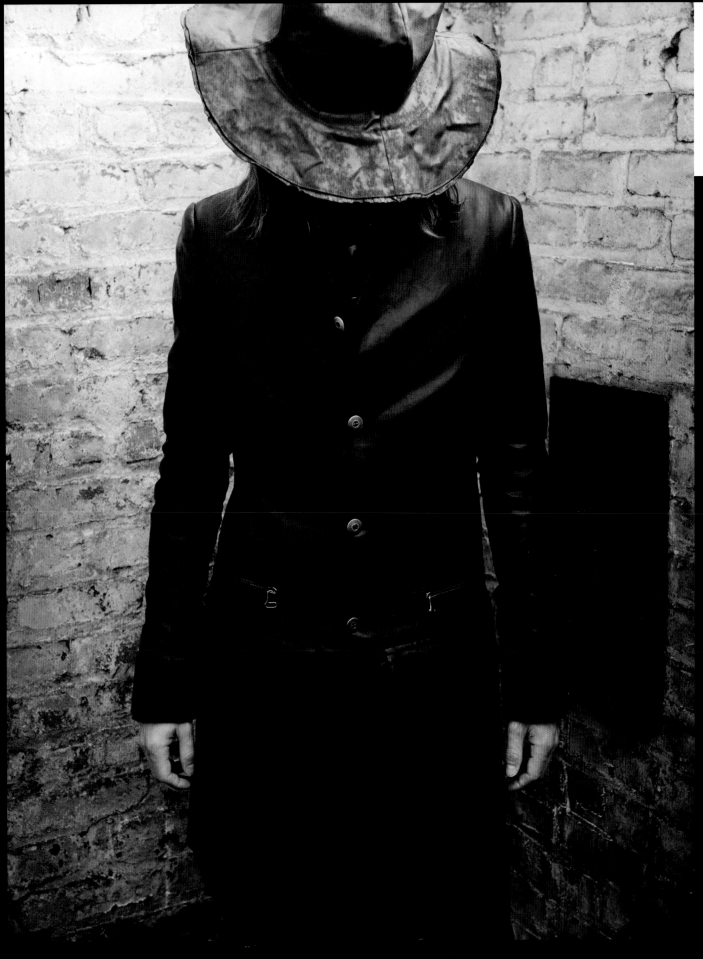

In Aisce autumn/winter 2010/2011

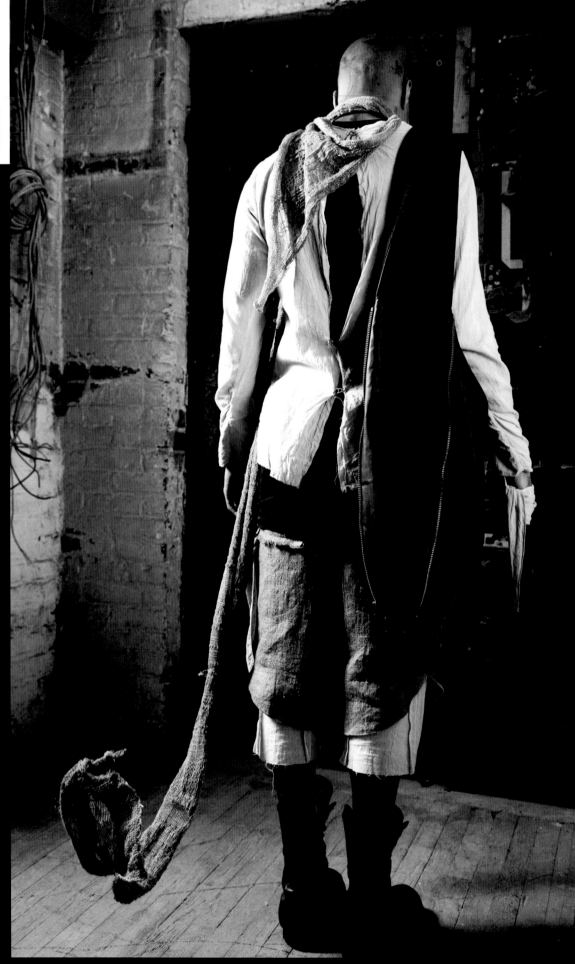

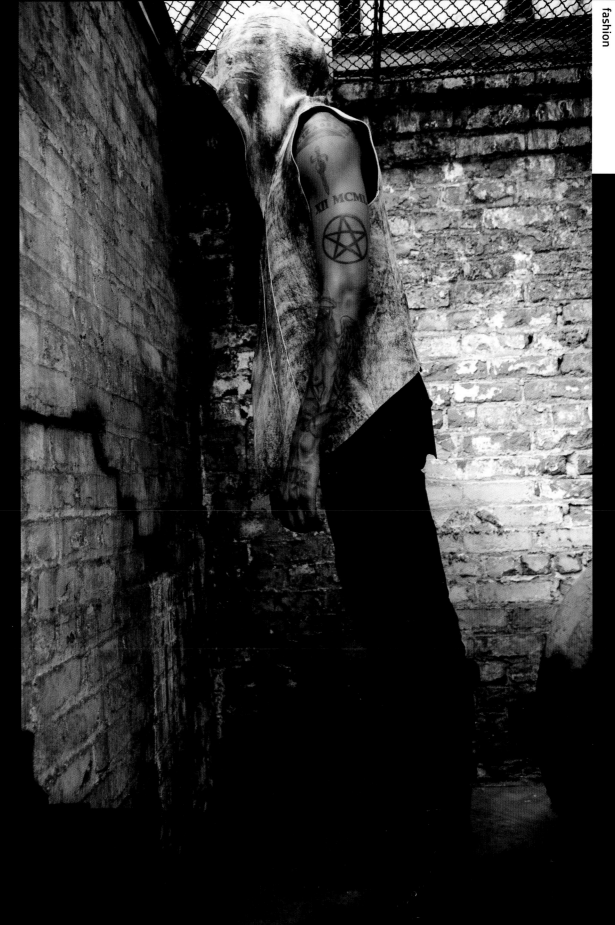

fashion designer

Mr. Pearl

http://www.michaeljamesobrien.com

With the discipline of Descartes and the patience of Job, the talented Mr. Pearl, *corsetiere extraordinaire*, surprisingly, travels light. His atelier, in the shadow of Notre Dame, is modest. In fact, Mr. Pearl is also modest, too modest even to admit to being a *corsetiere*, let alone *extraordinaire*. 'I am not a *corsetiere*. I have not attained that special knowledge. There are about five left in the whole world now who possess that art. I hope one day to be amongst them.' Clients like Dita von Teese, Kylie Minogue, Victoria Beckham and Betony Vernon, all of whom have been fitted, toiled and laced by Mr. Pearl, might disagree (as would this writer). So might John Galliano, Christian Lacroix, Jean Paul Gaultier and Thierry Mugler, among others (ALL the others), whose collections and runways have been enhanced by Mr. Pearl's creative collaboration. So might the private, unnamed clients (Mr. Pearl is also discreet) who depend on him to correct and perfect what nature left unfinished, or time has altered.

Some may be surprised to discover that a corset properly constructed (over three to five fittings) is not only a discipline but a comfort. Even if you are NOT longing for 'the Corset Moment' ('We seek a kind of sustained euphoria that may take you by surprise. We call it the "Corset Moment"') or even if you are not determined to ease several inches from your waist, a wearer will discover a new way of breathing, sitting and walking. As Mr. Pearl points out, historically, corsets were created for the ballet, where freedom of movement is a must. Or, as Betony Vernon puts it, 'I revel in that tight warm hug that does not ever ease, that is, until it comes undone and when it does, oh the joys of Mr. Pearl's. The memory of my impossible silhouette unfortunately lasts only about 30 minutes but it is a divine way to end the evening.'

Mr. Pearl began his journey in South Africa over forty years ago. The sight of his grandmother laced into her pale salmon coloured corsets made an indelible impression and set him on his way to becoming the *corsetiere extraordinaire* that he denies he is today. He next appears in London in the late 1980s at legendary clubs like Taboo, alongside his best friend, nightlife provocateur and performance artist, Leigh Bowery (who died in London on New Year's Eve, 1994). He also collaborated with Michael Clark on his early, seminal, dance pieces.

Since bouncing between New York, London and Paris, he has been installed in his current home on Ile de la Cité in the geographical heart of Paris, for six years.

Text and pictures by Michael James O'Brien

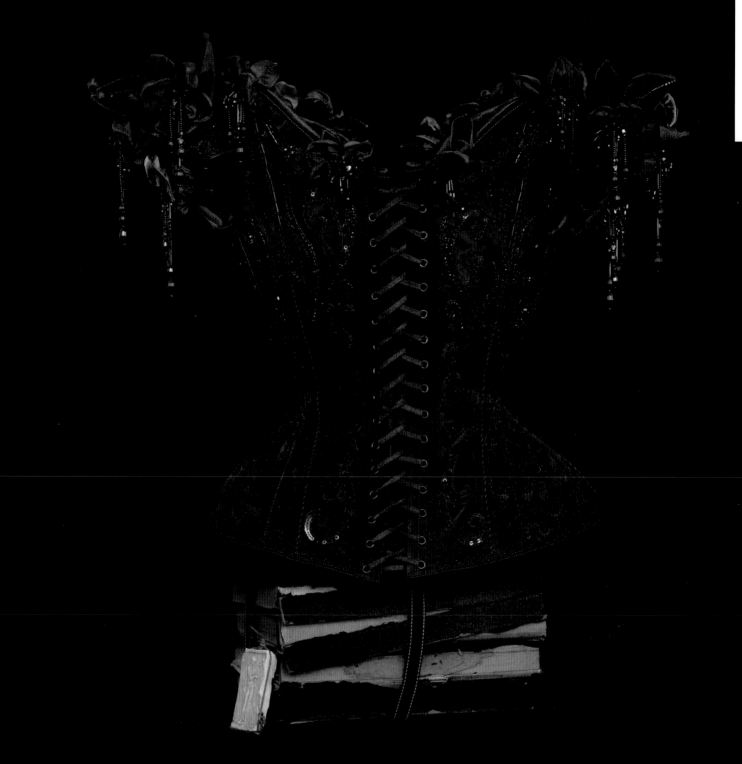

Mr. Pearl Still life with a corset

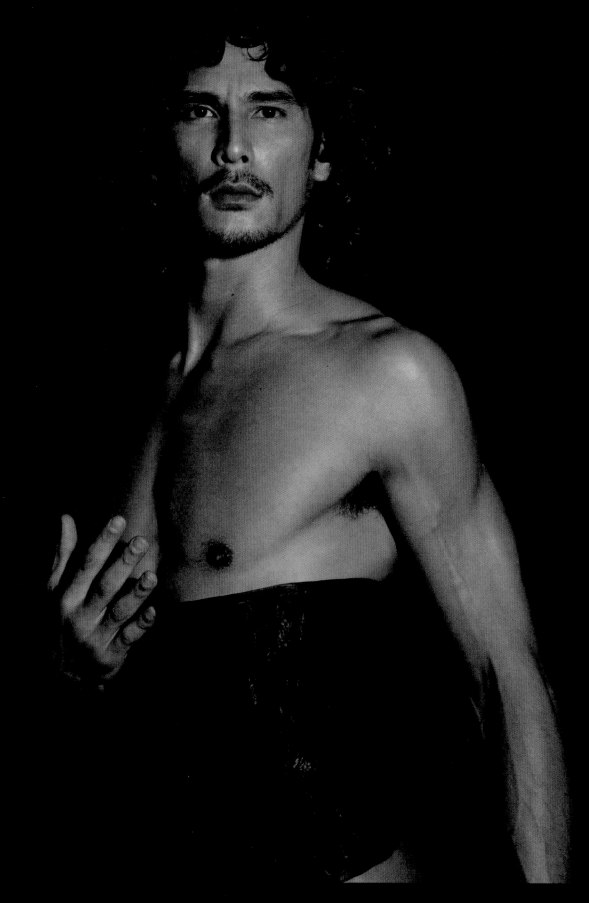

Luccino in Mr. Pearl's corset

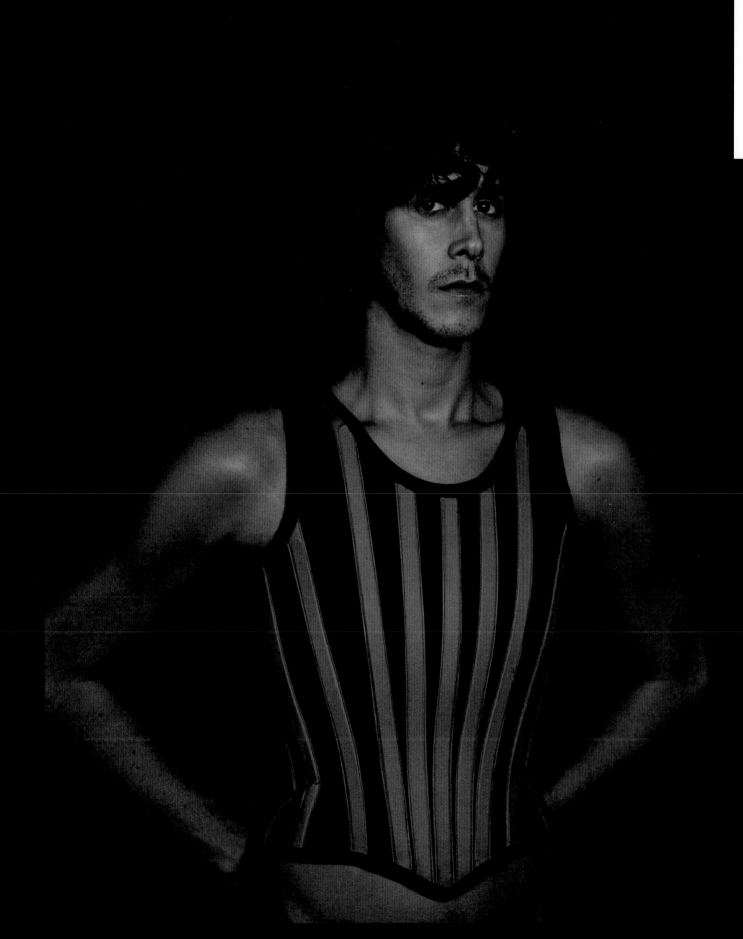

Cosmo in Mr. Pearl's corset

fashion designer

Georgy Baratashvili

http://www.georgybaratashvili.com

'I grew up in Moscow and I was always attracted to all sorts of art forms. I was painting, took up singing and piano lessons, and my biggest passion, dance. My family never stopped me from doing anything and I'm very grateful for that. So when the time came and I decided to cut up most of my mum's evening gowns for the sake of being "creative", I wasn't punished. I guess the path for my future career was set!

'I danced professionally until I was 21. Still love it, but I don't perform any more, well not on stage that is! So it's no wonder that movement inspired my collections of soft, draped pants and tops. When you are performing, all your clothes have to be very comfortable so you can move, and that's the quality I went for in my design. I've learned that everything must be comfortable.

'Moving on from my winter palette, I'm now exploring a cooler palette of inky blues, platinum greys and blacks, using high-tech jersey fabrics alongside a mix of sensual linens, silks, and leathers...'

Georgy Baratashvili's distinctively intricate drapery anchors the collection, alongside simpler, more commercial pieces enlivened with the designer's signature twist.

He created a film to launch his Spring/Summer 2010 collection as part of the On|Off showcase at London Fashion Week. Drawing inspiration from the designer's background as a dancer, the film is a collaboration with talented young choreographer Darja Reznikova, with male dancers performing a contemporary piece in garments from the new collection.

Baratashvili is a graduate of the internationally-acclaimed MA Fashion course at Central Saint Martins. He has won numerous international design prizes, including a Puma Bursary Award which led to two sell-out collaborations with the sportswear brand. His final MA collection launched Baratashvili as an exciting new face in menswear design.

His darkly romantic aesthetic combines inspiration from modern day youth culture with an evocative approach to materials — luxuriously draped jersey, slouchy wool, soft washed leather in nudes and greys — to create a vision of tough sensuality that has drawn worldwide interest and an audience which includes a growing number of female clients.

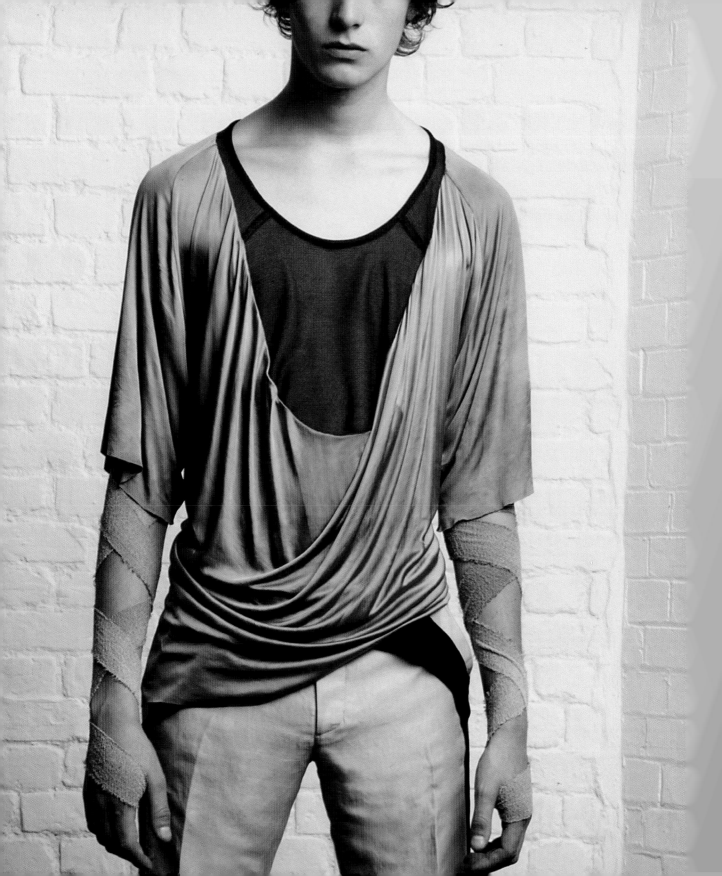

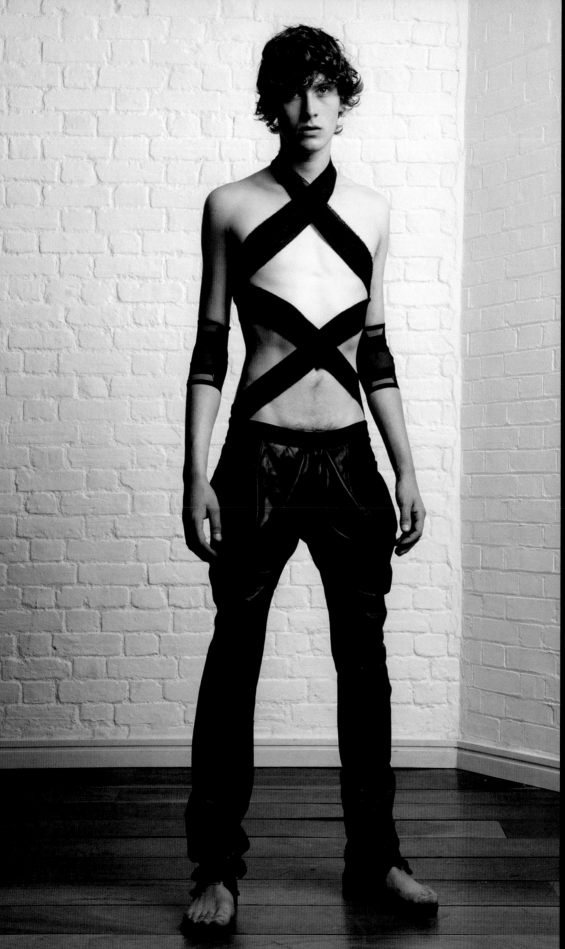

shoe designer

Marloes Ten Bhömer

http://marloestenbhomer.squarespace.com

'Ten Bhömer's experimentation with new shoe typology began when she was a child and slathered an old pair of her mother's shoes in papier mâché to exaggerate their shape. Twenty years later, when looking for a way to create a shoe of varying thicknesses, the Dutch designer remembered her mother's heels and began to experiment.

'In her efforts to change an object whose form has shifted only slightly over centuries, and with her wide-ranging investigations into unconventional materials, shapes and construction methods, Marloes ten Bhömer is a Hussein Chalayan for the extremities.' (*Wallpaper Magazine*, N° 37, 2005).

'My work' she says 'consistently aims to challenge generic typologies of women's shoes through experiments with non-traditional techniques and materials. By reinventing the process by which footwear is made, the resulting shoes are unique examples of new aesthetic and structural possibilities, while also serving to criticise the conventional status of women's shoes as cultural objects.

'My research into feet and footwear has culminated in a variety of experimental conceptual pieces, some of which have been developed into technically sound (wearable) shoes, and others which are produced solely as sculptural pieces. The existence of both directions within my practice adds a layer to my work; the context within which they sit, be it galleries, museums, or boutiques, challenges preconceptions about the shoe.'

Ten Bhömer's shoes are both provocative and other-worldly. Her work questions our perception of functionality, by fusing art and technology to create an origami-like production, working with materials such as wood, polyurethane resin, tarpaulin, steel and fibreglass.

Handmade in the UK, and incorporating technical expertise from international manufacturers, the special edition shoe shown on pages 39–41, the first to be commercially launched by MARLOESTENBHÖMER®, is a truly unique product.

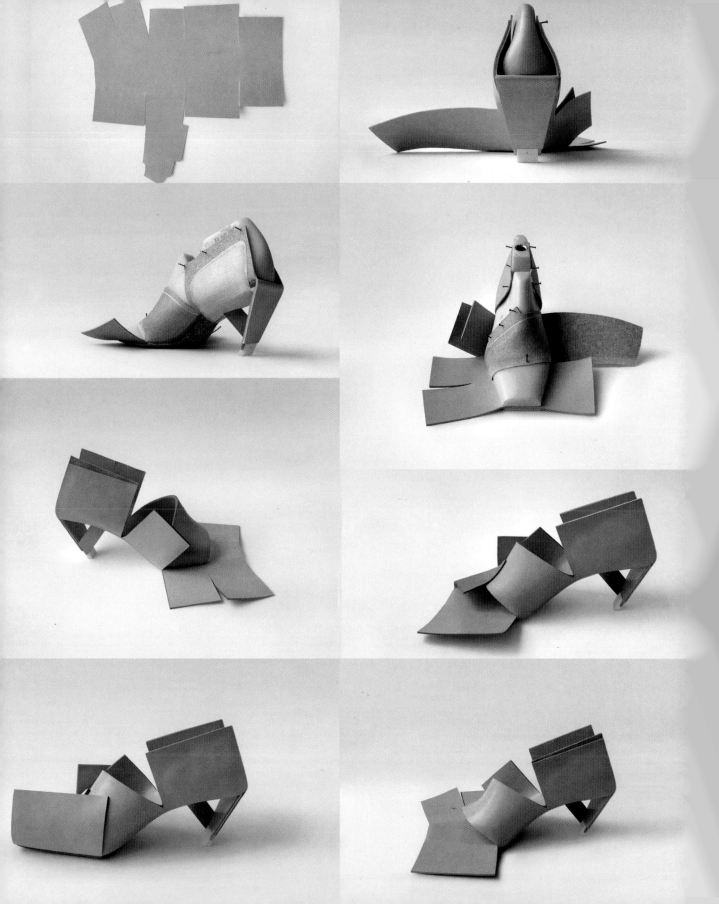

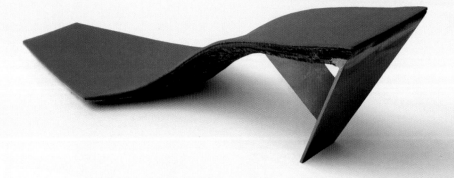

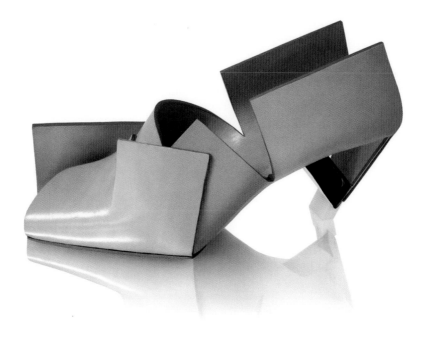

shoe designer

Alexander Fielden

http://www.alexanderfielden.com

We live in a world where getting older is seen as a malformation and the effects of this natural aspect of life are generally brushed or polished away, rather than seen as a sign of becoming wiser. Life is perfect the way it is and we are denying this. It's like Leonard Cohen sings, 'Forget your perfect offering, There is a crack in everything, That's how the light gets in'.

I translate this way of thinking, whereby beauty is based on real life, in my work. The cracks and malformations in the textures and forms make it feel like there is a life already in these shoes. These 'pathwalkers' have strong imperfect forms; just the way things are in life. I see the beauty in that. They have wrinkles, burn marks, scars and tick bites, as though they've walked a rocky path.

– Alexander Fielden

(photos by Christian Fielden)

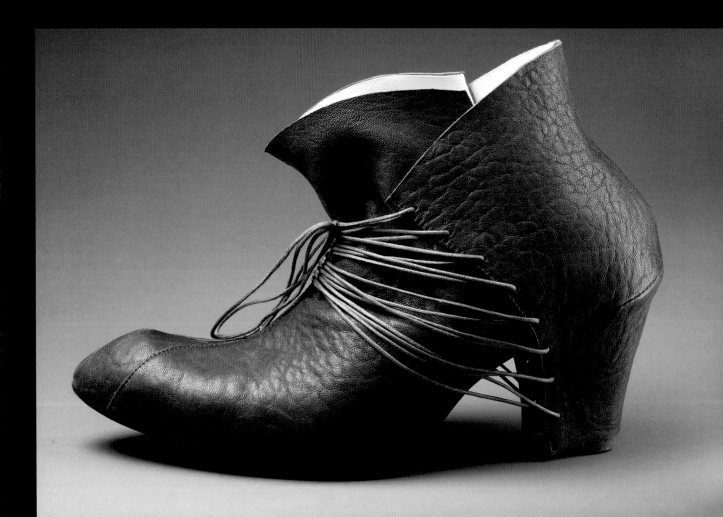

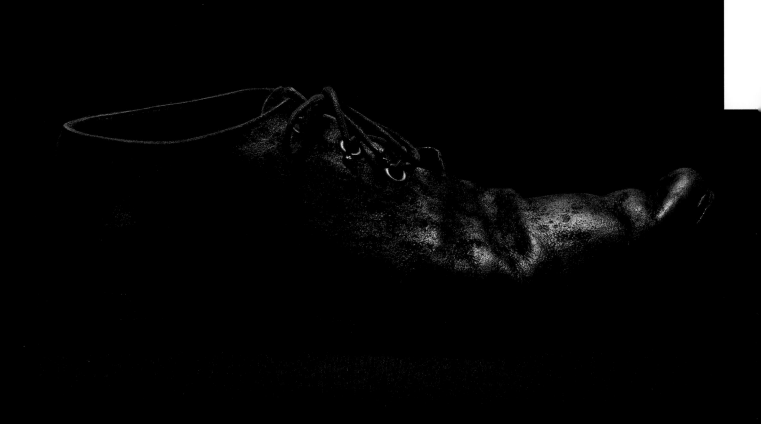

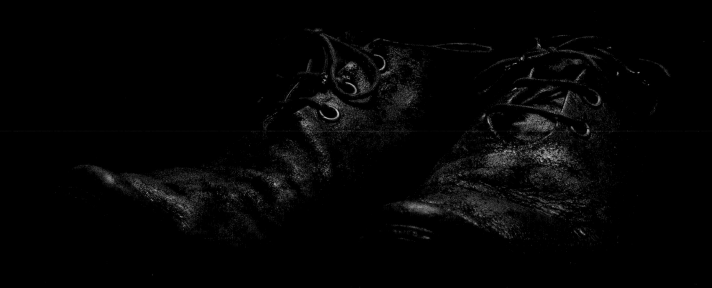

Alexander Fielden

shoe designer

Nicholas Kirkwood

http://www.nicholaskirkwood.com

An alumnus of prestigious design schools Central Saint Martins and Cordwainers, 27-year-old British designer Nicholas Kirkwood launched his eponymously-named collection in Spring 2005. The collection of architecturally-inspired pieces, with a blend of genres that subvert the relationship between tradition and modernity, instantly won the attention of Grace Jones, Daphne Guinness, the late Isabella Blow and Cecilia Dean of *Visionaire*. Rave reviews also came from industry insiders.

Craftsmanship plays an integral role in all of Kirkwood's collections. Such perfection of craftsmanship has a stylistic value. This is highlighted by geometric forms and strong clean lines inspired by architectural and sculptural shapes. Kirkwood's shoes are free of excessive decoration, with the focus always on innovation of linear forms. Unusual skins and techniques are omnipresent: shaved stingray, laser-cut mirror leather, cobra, rubberized leather, buffalo horn and sueded alligator. Seasonal trends appear unintentionally and are always at the forefront of the *zeitgeist* rather than following or emulating it.

Kirkwood's shoe-making talent makes him much sought after by the design community; he has collaborated with an array of established and emerging designers such as Gareth Pugh, Zac Posen, Phillip Lim, Doo Ri, Boudicca, Belstaff, Basso & Brooke and Louise Goldin. French fashion house Chloé employed him to consult on their Autumn-Winter 2007 collection.

The Spring/Summer 2008 collection won a prestigious AltaRoma award for accessory design, as well as the commendation of André Leon-Talley, *American Vogue's* Editor-at-Large, and Franca Sozzani of *Vogue Italia*.

Nicholas Kirkwood shoes can be found in leading boutiques and department stores around the world including Dover Street Market, Harvey Nichols, Browns (London), Jeffrey (New York), Le Bon Marché (Paris), Podium (Moscow) and On Pedder (Hong Kong.)

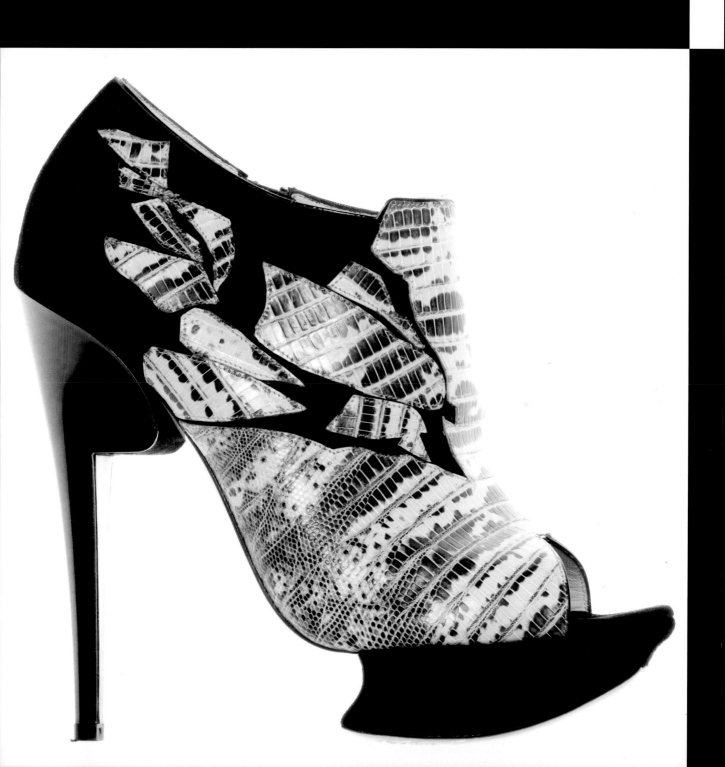

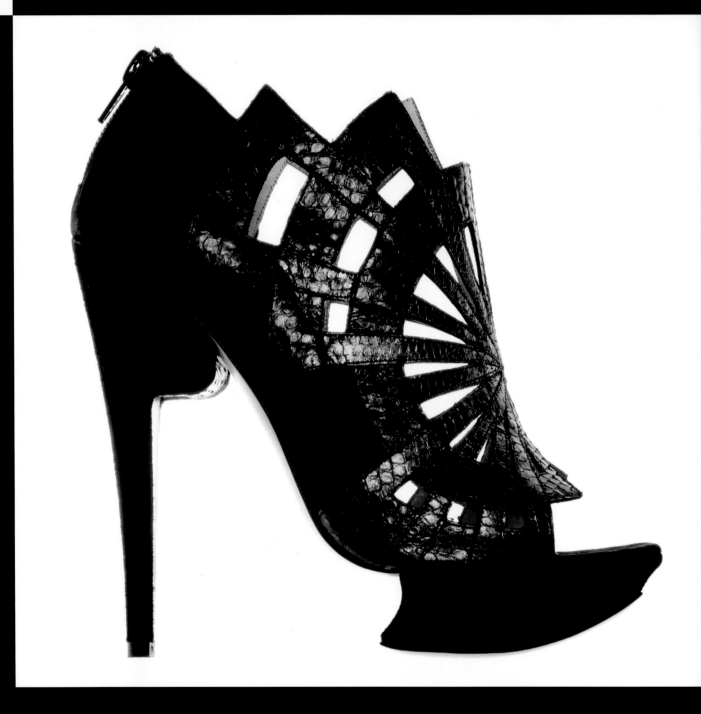

Nicholas Kirkwood A9074A

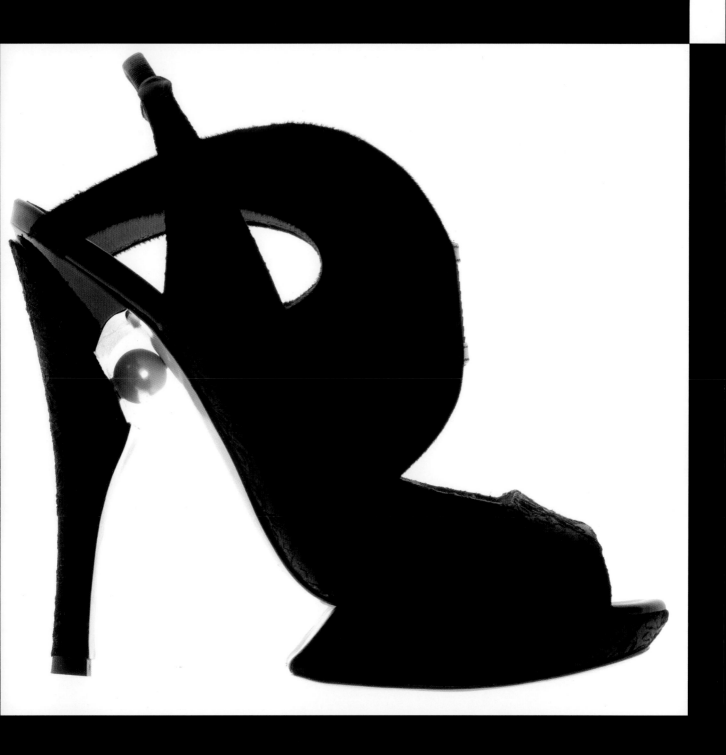

Nicholas Kirkwood AW08 012

Virtual Shoe Museum

http://www.virtualshoemuseum.com

I'm Liza Snook (44), director and founder of the Virtual Shoe Museum, online since 2006. I'm a graphic designer by profession. My partner Taco Zwaanswijk, a multimedia designer, designed the site. The video reports that are shown are also made by us. I was born with a passion for shoes and I have been collecting now for more than 25 years. My collection consists of a library of shoe books, shoevenirs, shoes I can wear (wearing doesn't necessarily mean walking!), shoes from different cultures and hundreds of Barbie shoes.

For some twenty years I showed my collection of shoes, shoe images, advertisements, photos etc., at home to whoever was interested, telling the same stories over and over again... Now, of course I always visit shoe museums when I'm abroad. Most of the time, however, this proves to be disappointing as there is not enough space to present a substantial part of the collections and there is little context. These experiences inspired me to create a virtual shoe museum, with the range of possibilities that a digital environment opens up.

We include shoes in all sorts of sections, without having to compromise or duplicate. We create multiple perspectives, from 'designer', 'focus' and 'material' to 'style', 'type' and even 'colour'.

Each time, a new environment is created in which the shoe is presented. At the moment there are 1100 shoes in our virtual collection, and we are working on many more.

The core of our virtual collection focuses on designs that question the very essence of the shoe: Is this a shoe? Is this wearable? Does it matter? Does it tickle your imagination? Designs that balance between these values and still present a shoe that can be worn, or looks like it can, are what I'm after: a twist, a sense of humour.

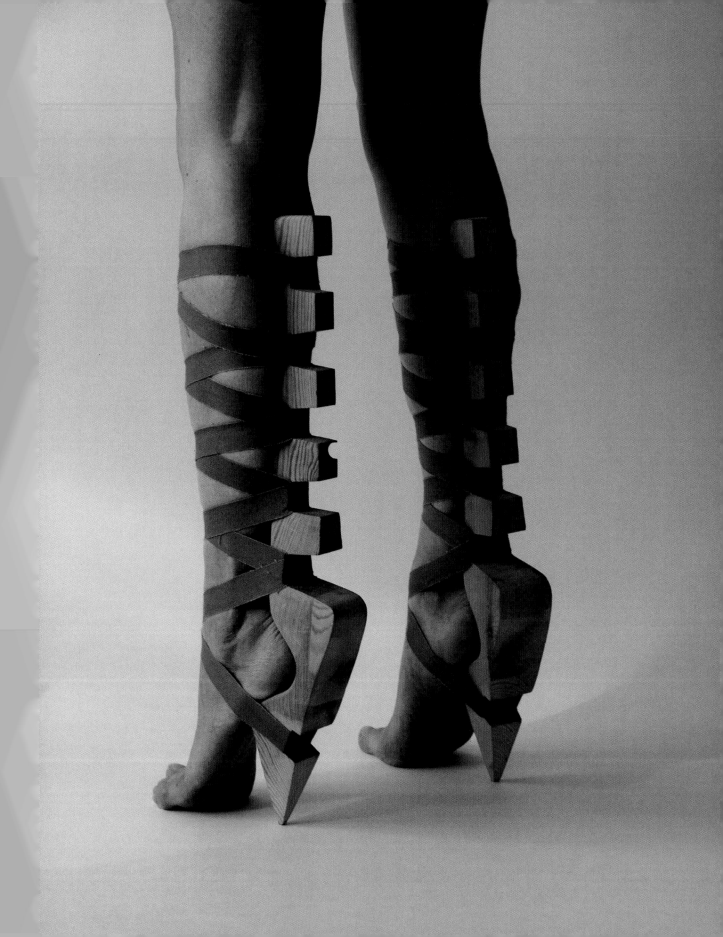

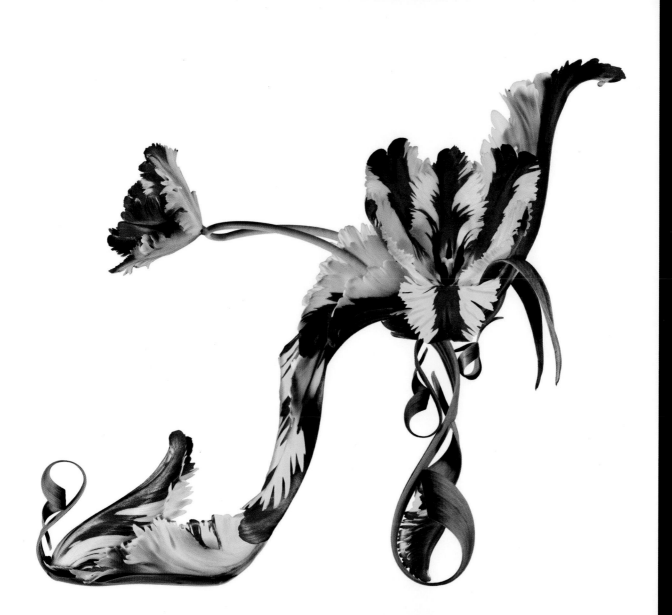

glasses designer

Oliver Goldsmith

http://www.olivergoldsmith.com

Think 20th century icons: Grace Kelly, Michael Caine, Audrey Hepburn, John Lennon. Think iconic style-makers: Givenchy, Dior, Vidal Sassoon. Think iconic films of the 1950s and 60s: *The Ipcress File*, *Breakfast at Tiffany's*, *Two for the Road*. They've all got one thing in common: Oliver Goldsmith.

In the second half of the last century, when it came to eyewear, Oliver Goldsmith was synonymous with stars and style.

Oliver Goldsmith is a family business, founded in 1926 by Philip Oliver Goldsmith, a salesman for a small optical firm. At the time, spectacles were uncomfortable, unflattering and uninspiring. The choice of materials was limited to expensive tortoiseshell or cumbersome metal.

Goldsmith set out to transform the way that glasses were both designed and made.

In 1935 Charles Goldsmith entered the family firm. His vision was that glasses could become an item of fashion, especially when worn as sunglasses. Until then, sunglasses were any old pair of specs with tinted lenses. Charles designed glasses that were made to be sunglasses.

His first two customers for the new 'sunspecs' were the most prestigious stores in London: Fortnum & Mason and Simpsons of Piccadilly. They sold out within a week. Sunglasses had arrived.

'We were the first to see glasses as fashion accessories; the first to make sunspecs, the first to make winter sunglasses, and the first to work with fashion houses to create one-off pieces for the catwalks. We were the first to appear in *Vogue* and *Queen*, and the first to be endorsed by celebrities and royals. Oliver Goldsmith pioneered a whole new concept: Eyewear'

The stars who beat a path to Goldsmith's Poland Street showroom included Grace Kelly, Peter Sellers, Ursula Andress and Olivia Newton John. The visitors' book they autographed can still be seen today in the Oliver Goldsmith showroom.

54

Oliver Goldsmith A4 OG6545

Oliver Goldsmith A4 OG6622

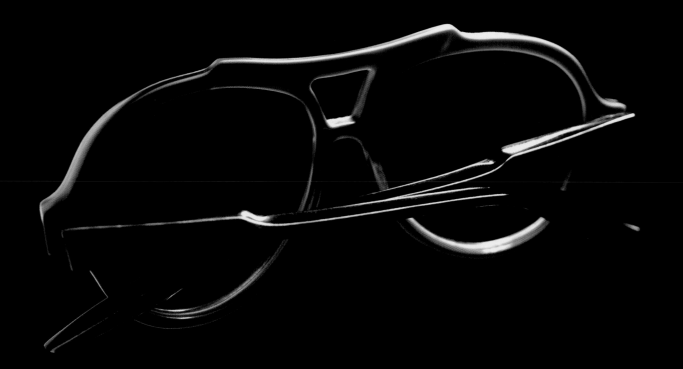

Oliver Goldsmith A A4 OG7072

glasses designer

Christian Roth

http://www.christian-roth.com

Our vision of vision. There is sight and there is vision. Vision isn't just what we see; it's how we see it. The mind has an eye of its own. Vision means seeing with intelligence and imagination. We want to improve people's sight while we enhance their own personal vision. Vision is a two-way street.

Life is about seeing and being seen. We want people to see perfectly and look that way too. Since 1984 we have worked to create glasses with vision for men and women.

We are pleased that for over 25 years our designs have been worn by visionaries around the world. And in turn, our customers are great inspiration for our art. Our vision keeps us at the forefront of design, imagination and technology. We don't want to be scientists if we can't also be artists. We think of our collection as art, that's why we strive for perfection in techniques and uniqueness in design.

– Christian Roth and Eric Domège.

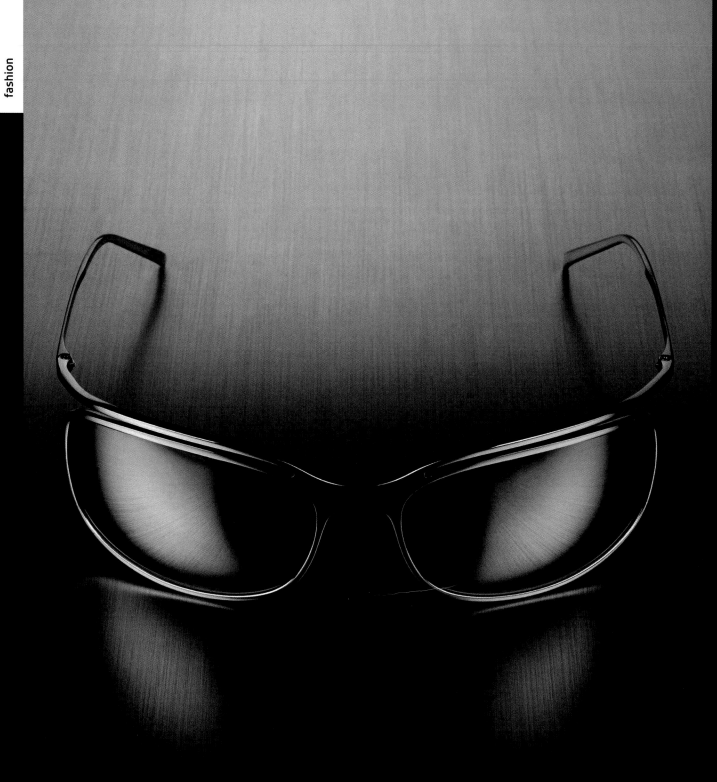

Christian Roth Model OWNusa2 2007 parrution

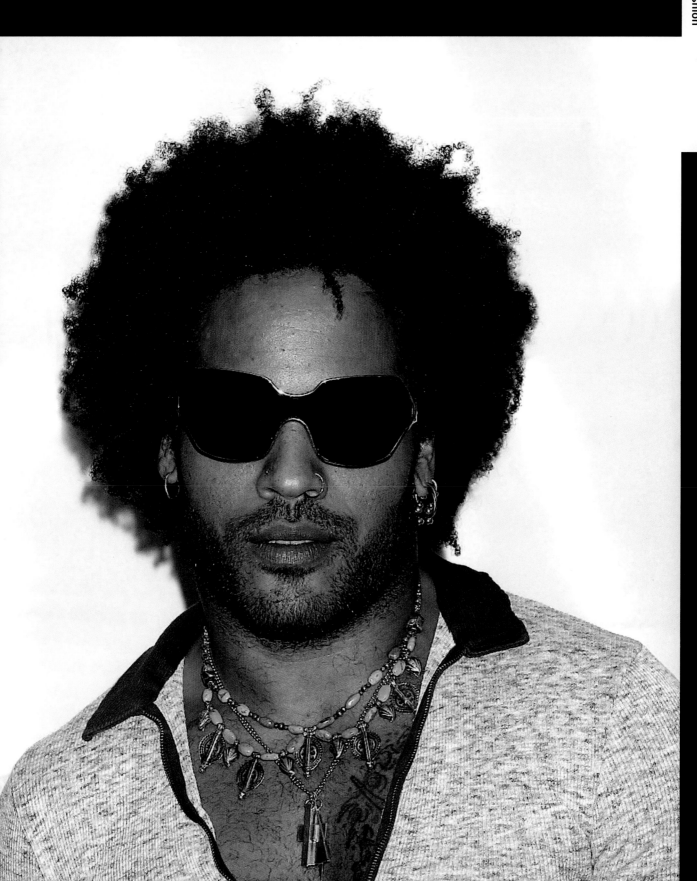

bag designer

Nico Uytterhaegen

http://www.nicouytterhaegen.be

Nico Uytterhaegen is a Belgian designer who creates leather goods using the most refined leathers. His brand was launched in 2006 during Milan Fashion Week and has been perceived by buyers and international press as innovative avant-garde.

Since he was very young, Nico has been intrigued by art, painting and architecture, and inspired by the subcultures of the alternative fashion and music scenes. These different disciplines contribute to bring innovation into his work.

Nico constantly plays with new forms, proportions and details. Construction and deconstruction, symmetric and asymmetric forms, are the guiding themes throughout the process. He adds no decorations, just the purity of the design and material create the character of his bags.

And turning his back on the classic bag, Nico is a master in tailoring and shaping bags that become like a second skin: the natural tanned leathers give the bags a perfectly natural feeling, creating objects that fit the body. Inspired by the complexity of men's psychology, his bags may look strong, carefully hiding their sensitivity. You only discover the sensitivity when you take the time to explore; when you touch them, you feel the softness.

Nico Uytterhaegen Flower

Nico Uytterhaegen Fingertip

bag designer

Assef Vaza

http://www.v-a-z-a.com

I design for women who have neither the need nor the time for oversized handbags. Inspired by the time-honoured practices of the haute couture houses and by the larger-than-life eccentricities of society, the focus of my creation is ' whimsical refinement'.

Launched with a handful of colourful lizard pieces, the structured clutch bag has fast become my signature. The astute melange of shape and form, combined with influences of couture, with bold colours and kooky materials, result in a contemporary potpourri of new luxury.

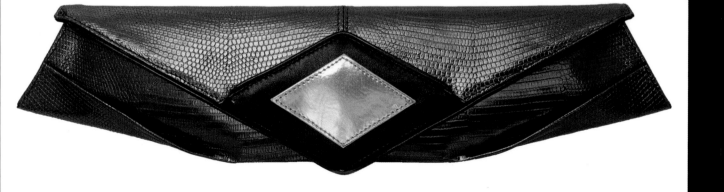

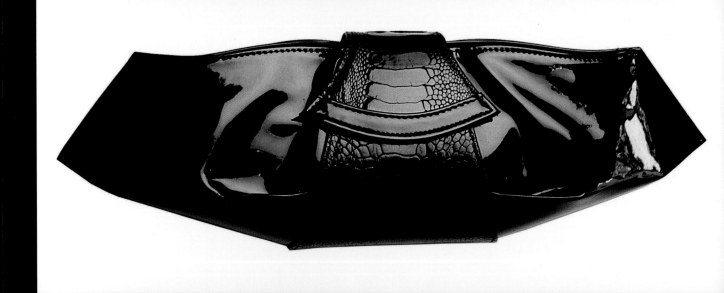

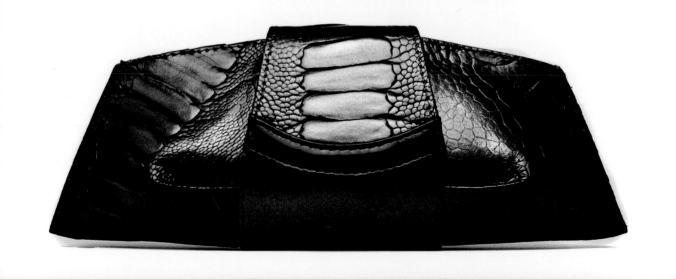

hat designer

Noel Stewart

http://www.noelstewart.com/

The hats I design for men and women are modern but classic, elegant but never predictable, fresh but not violently so.

I combine the heritage and language of fashion millinery with my own cultural heritage to create richly textured hats that speak of landscape ... metropolis ... painters ... architects ... designers.

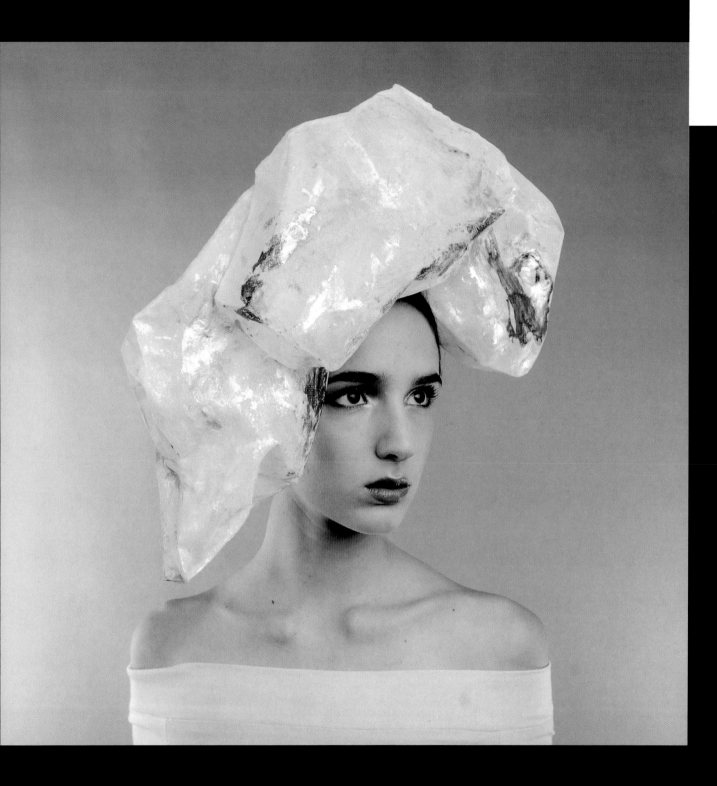

Noel Stewart

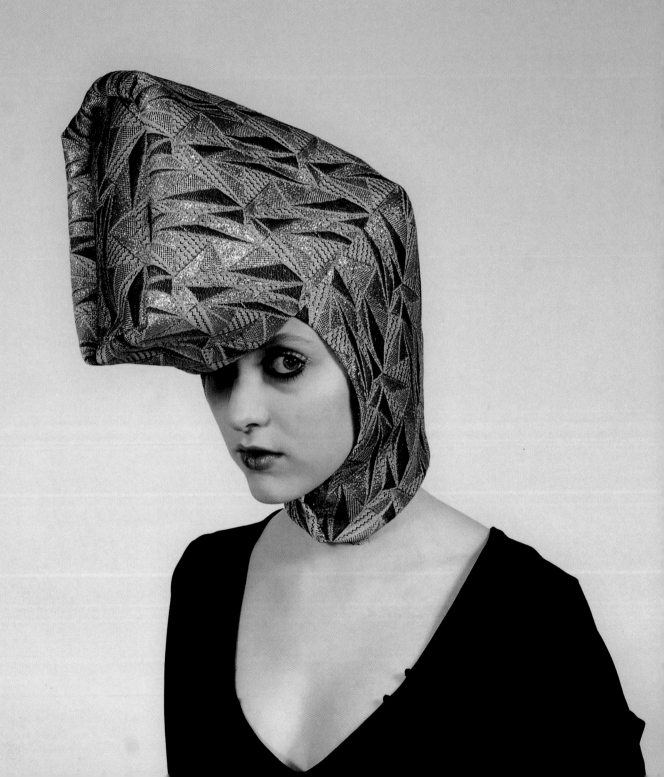

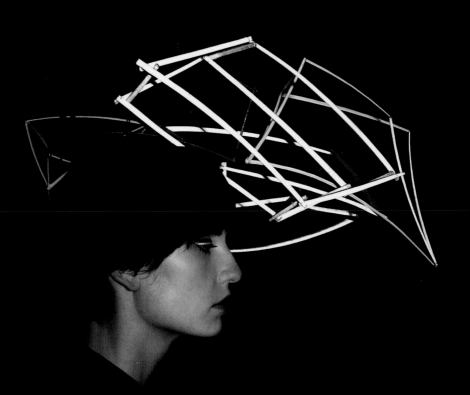

hat designer

Irene Bussemaker

http://www.irenebussemaker.nl

It's very hard to describe my own work. It's like describing yourself, and I don't like to be put in a box. Some say I have a 'dark sensitivity' or call my hats eccentric. They've also been described as sculptural, glamorous and inventive.

Unlike most designers, I don't use drawings because I don't want to know upfront what the end result is going to be. It's not just that it makes sense to me. I love the element of surprise!

Things that inspire me? Britney Spears shaving her hair! She made me wonder how she would look without and why she should hide. I made an entire collection in 2007 called 'Wiggy'. The hats refer to hairstyles but never become wigs. They have acquired a look of their own. And another source of inspiration: traffic warning signs.

My new collection, High Voltage, is about the financial crisis. It's like an electric shock, which is how I think of the financial crisis'.

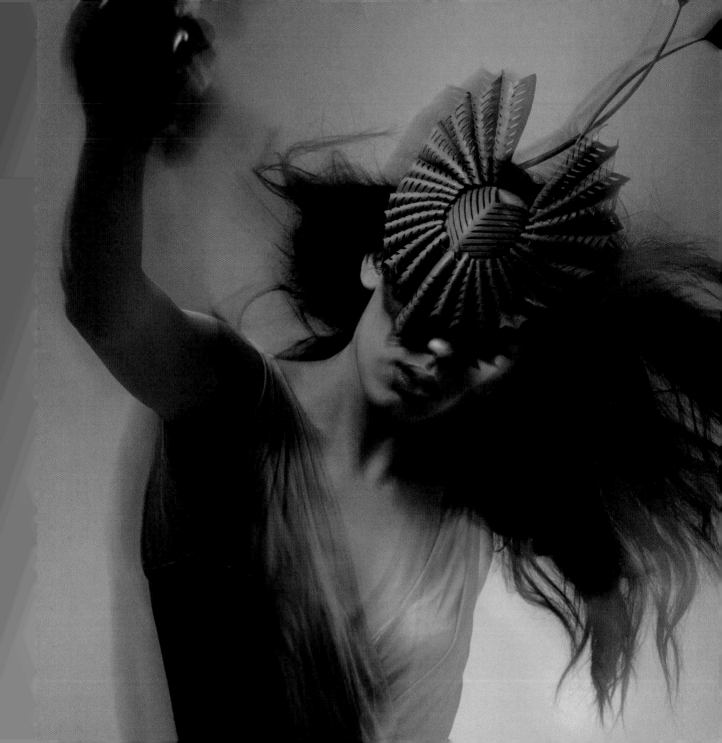

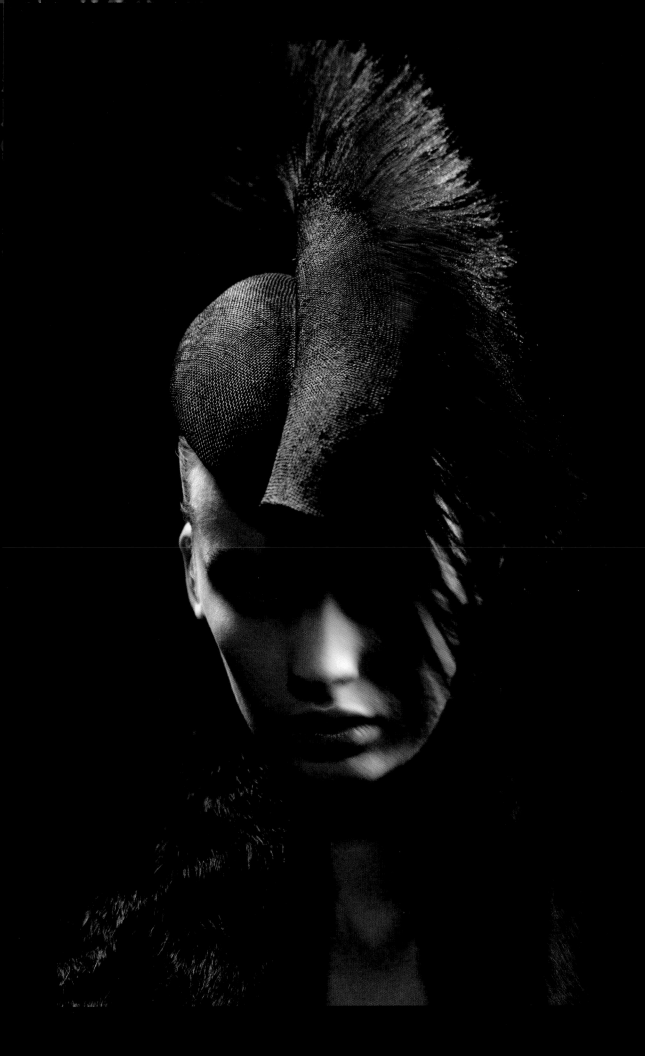

pho

togra

phy

photographer

Miss Aniela

http://www.missaniela.com

Miss Aniela (aka Natalie Dybisz) from Brighton, Sussex, poses for, photographs and processes her own photographic portraits, often cloning herself several times in a single image. She demonstrates the endless possibilities of playing a character – or several – in her photographs and of being her own muse. The sense of spontaneity, simplicity and wantonness throughout her work comes from being completely at one with the camera.

'Making self-portraits has become a form of ritual – I am obsessed.'

With her unconventional beginnings as an entirely self-taught photographer, it's a real achievement that this young talent was recently featured on the cover of the prestigious *American Photo* magazine. Since launching her career via photo-sharing sites on the internet, Miss Aniela accrued over a million views within months before going on to secure her first solo exhibition. Three years on, she sells her work as fine art limited edition prints through galleries and art fairs as far afield as Madrid and Miami. Now sought-after for commissions, the rapid interest in Miss Aniela proves she is set for stardom beyond the realms of the worldwide web.

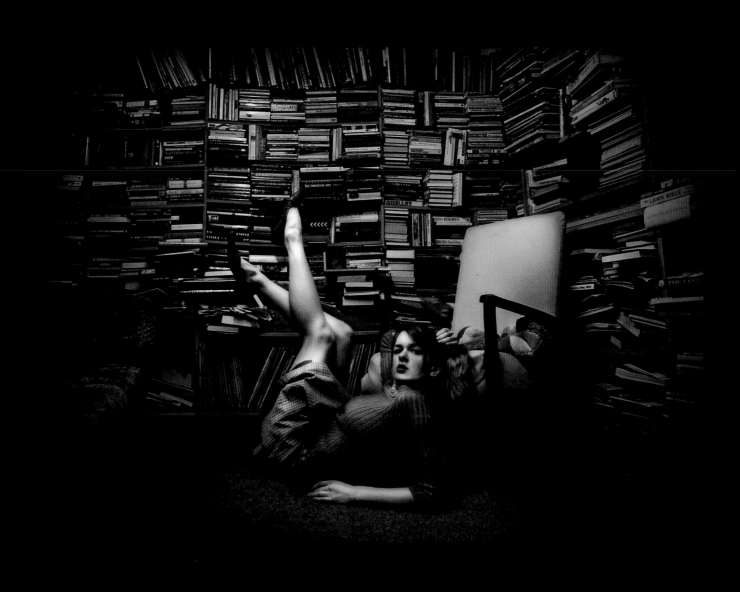

Miss Aniela Pink & read

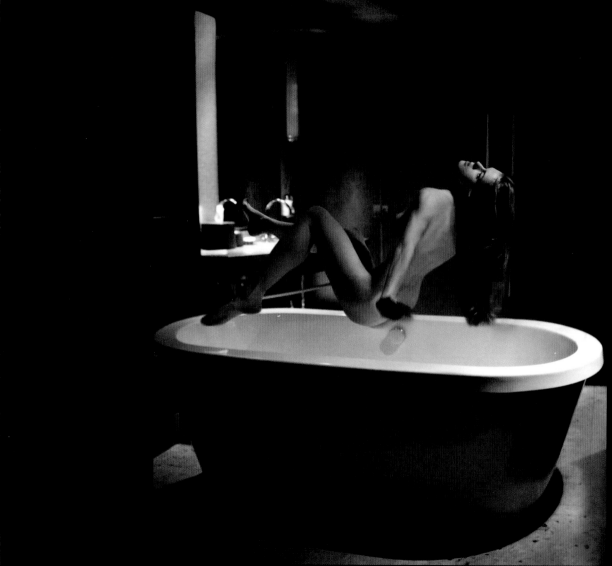

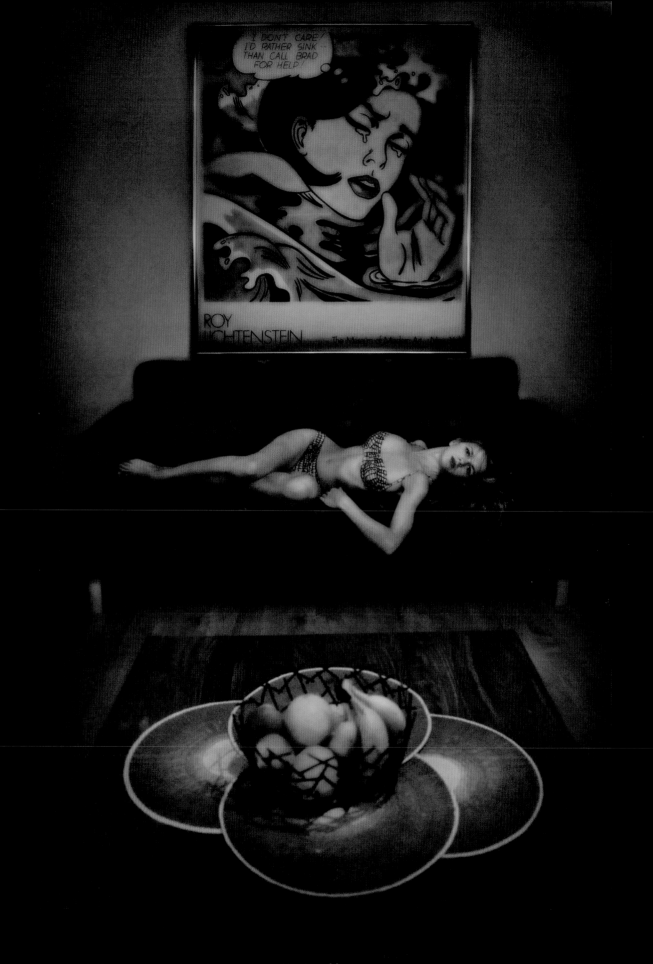

Miss Aniela Portrait with Lichtensein and a thorned basket of fruit

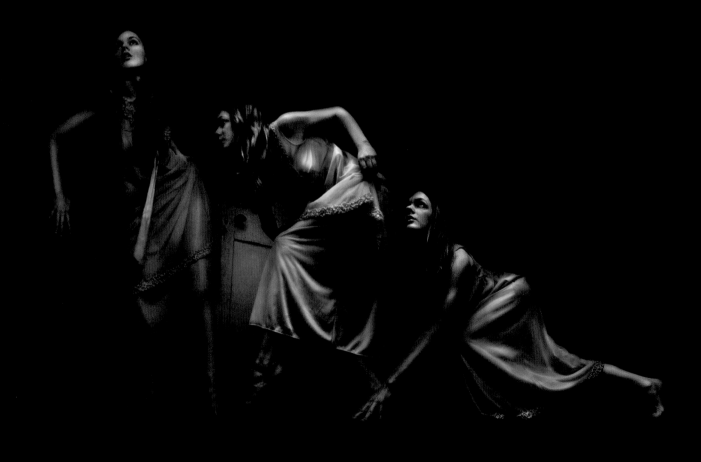

Miss Aniela If only I could touch her cloak

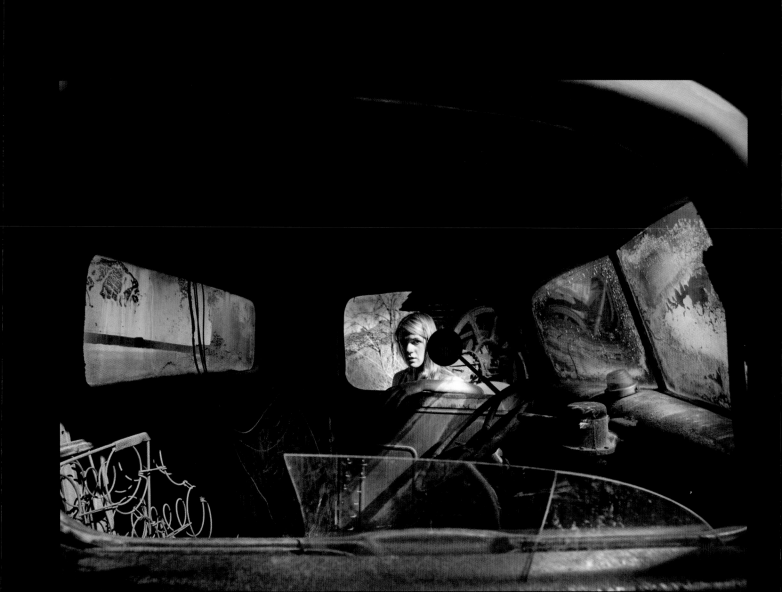

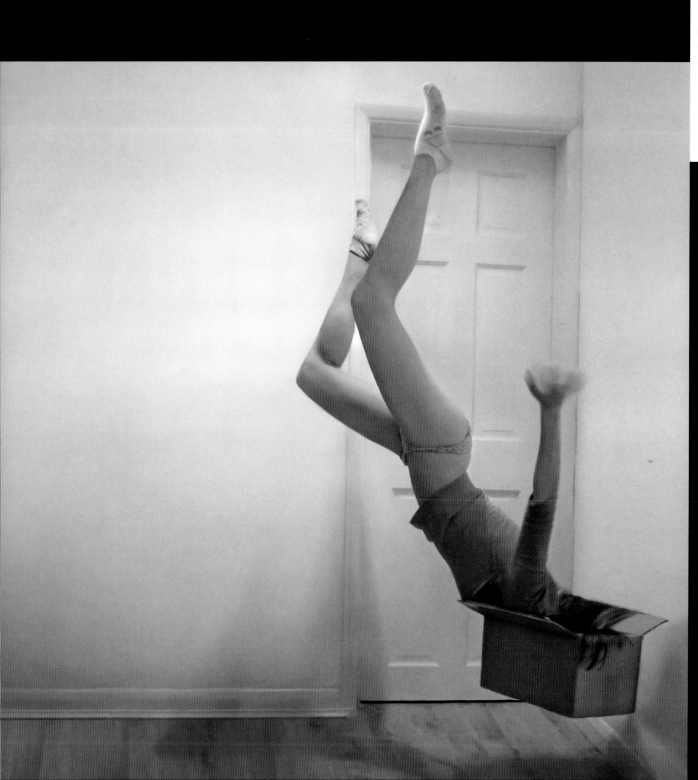

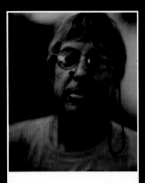

photographer

Ken Merfeld

http://www.merfeldcollodion.com

I believe that interesting people make interesting portraits and I have always enjoyed the dichotomy of man as revealed in a venue of trust. Every person embodies a range, from strength to weakness, from beauty to strangeness, from the familiar to the unexpected, in their persona. To tap into inner truth rather than a façade, to embrace honest emotion over a flight of fantasy and to construct this provocative truth on a simple piece of glass is part of what the wet plate collodion process is about.

The world in which we live is not perfect, nor are the people who inhabit it. And neither is this chemical process. Each plate is unique and embraces imperfection in its interpretation.

This amazing process is simple and complex; beautiful and imperfect; classic and timeless; universal yet individual. It yields opera of the most personal kind. It opens doors into people that other processes do not. It is what I must do.

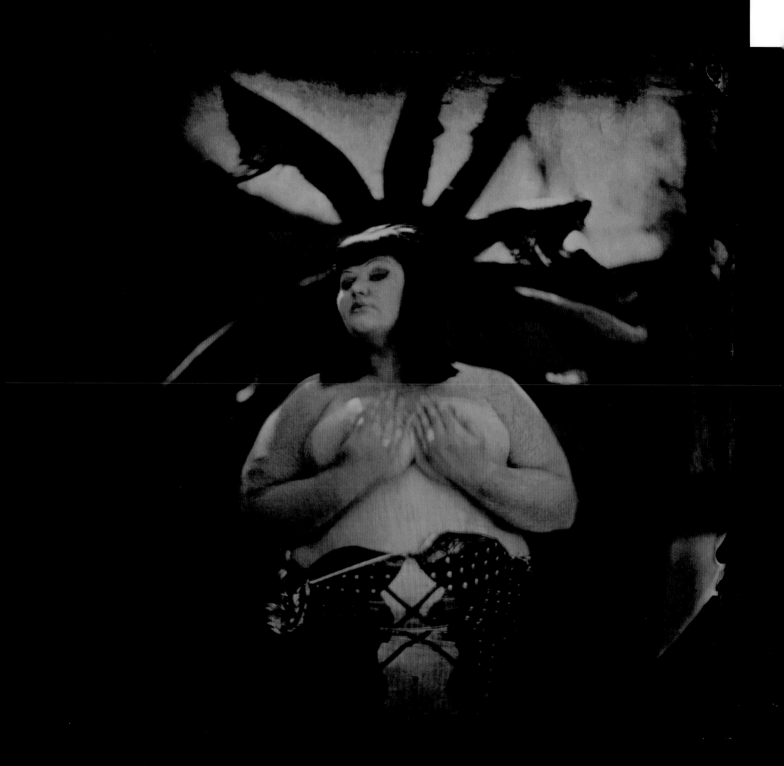

Ken Merfeld Morganstar

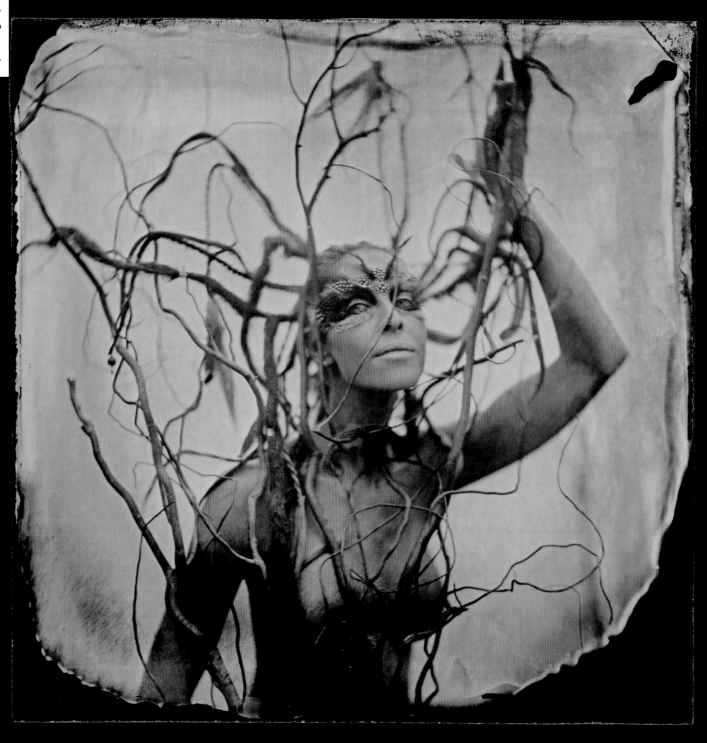

Ken Merfeld Gethsemane

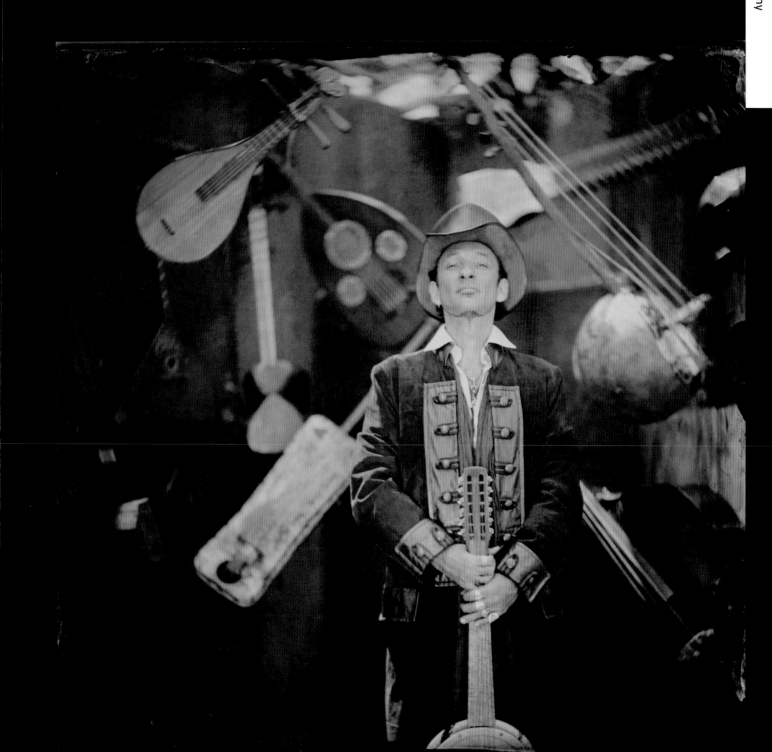

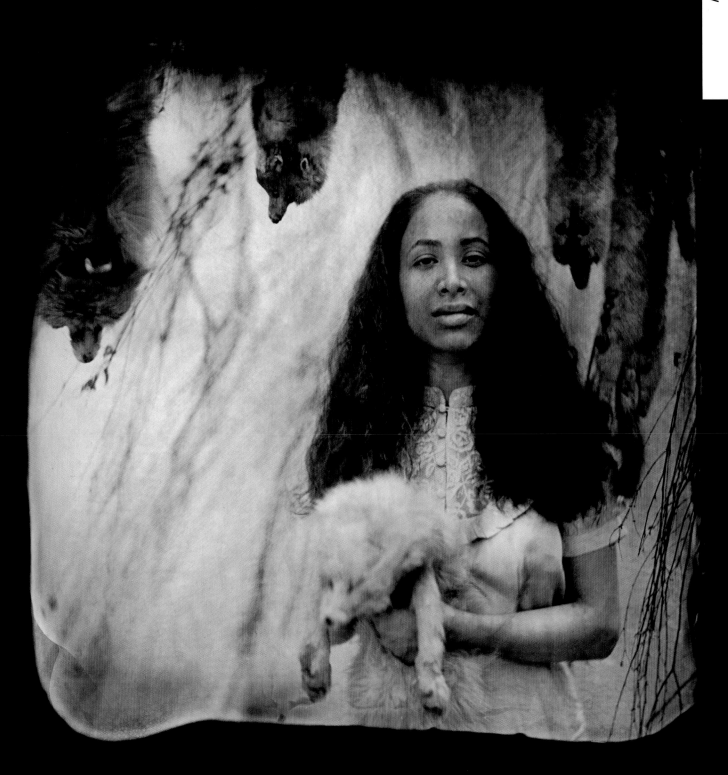

Ken Merfeld Fisherqueen

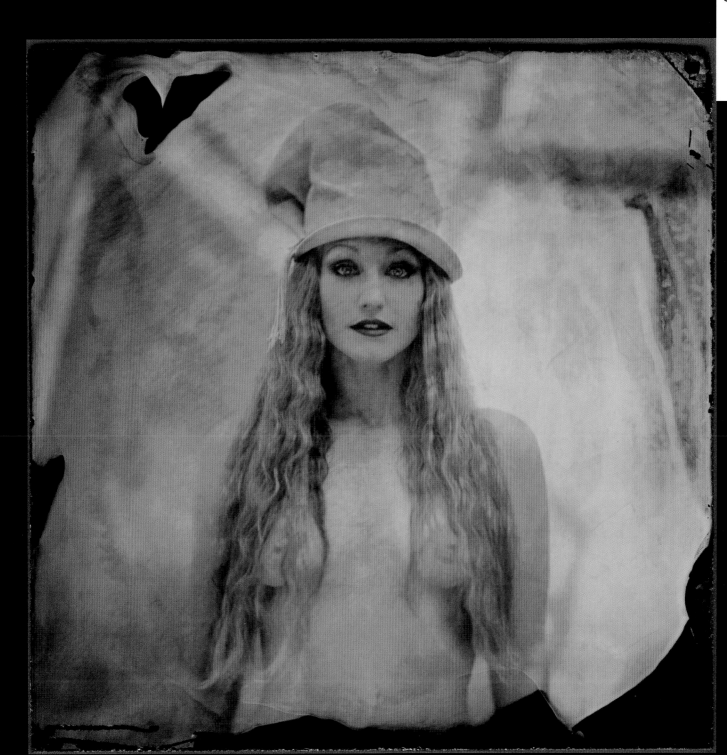

photographer

John Stoddart

http://www.johnstoddart.co.uk

John Stoddart has been a photographer for over 25 years and is highly respected in his field. He has worked for nearly every magazine in the UK and internationally: *Vanity Fair* and *The New York Times*, among others.

To date, John has had two books published, *It's Nothing Personal* in 1997 and *Peep World* in 2004, both of which explored the illusive world of fame. Of his numerous exhibitions, the major ones were Punks, Poets and Other Stars, 1995; It's Nothing Personal, 1997; Peep World, 2004, and Society, 2006.

He is currently working on two further exhibitions with the working titles of Dirty Little Picture – a portrait of British Pornography and Instant Alchemy, which is made up of almost 200 Polaroid images taken by John over the last 20 years.

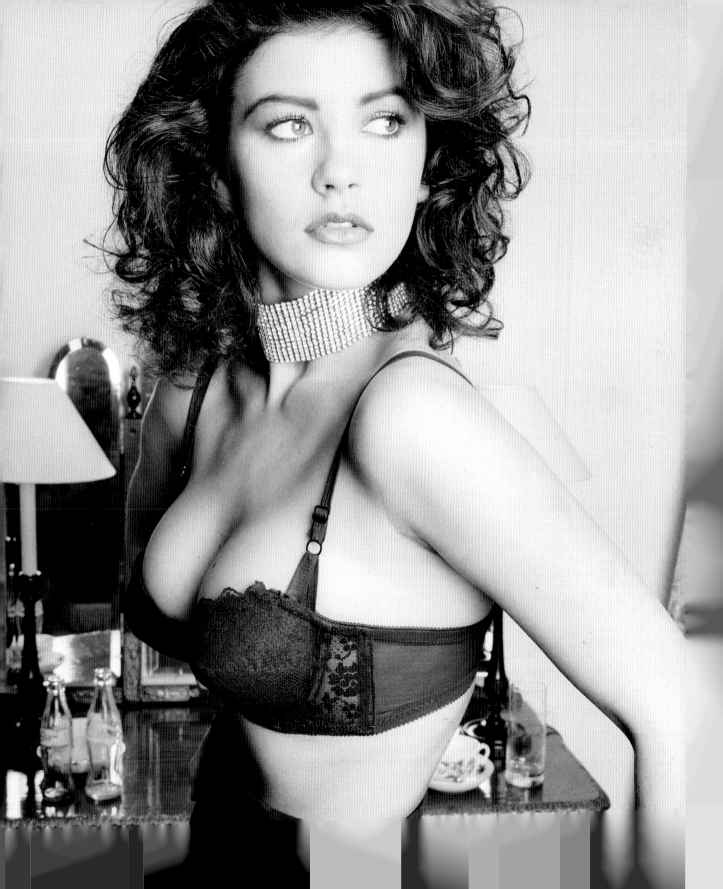

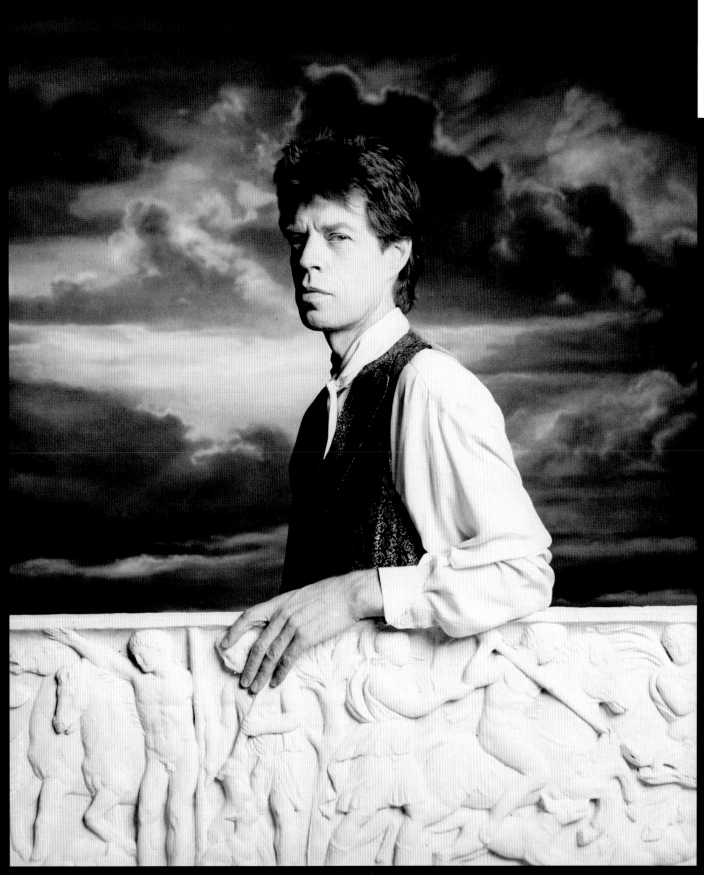

John Stoddart Mick Jagger

73

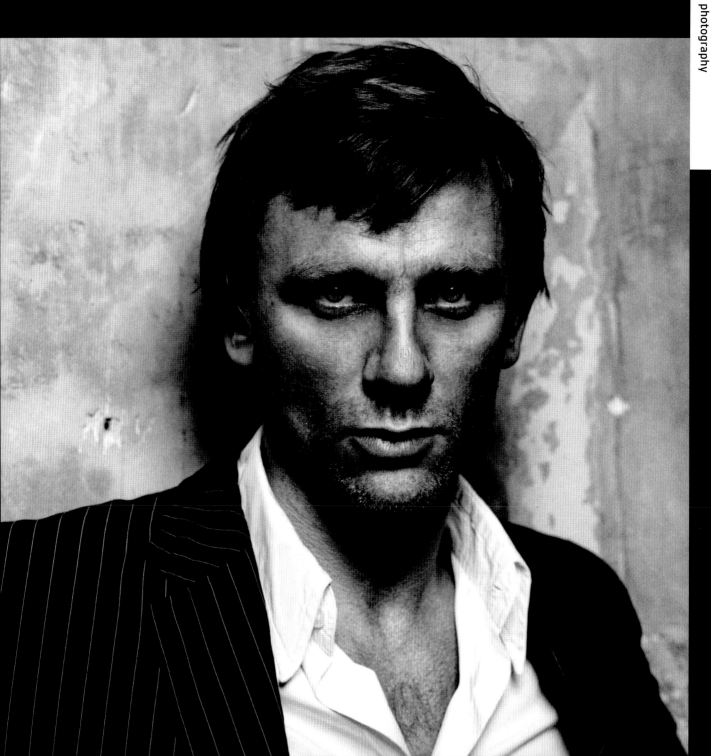

photographer

Jamie Baldridge

http://www.jamiebaldridge.com

My love of stories goes all the way back to childhood when I discovered a book called *101 Fairy Tales* in an old steamer trunk in my grandmother's attic. The picture on the pale blue cover, nibbled with flaking and tarnished gold leaf, was of a turbaned boy on a magic carpet. I sat in dusty, humid silence, among the jaundiced communion gowns and mildewed *lettres d'amour*, reading by the second-hand light of the attic window, enchanted by the riotous jewel-like illustrations of the foxed and dog-eared pages.

I suppose I became an artist on that boring Saturday afternoon in that attic. Ever since, I have sought to evince in the viewer that same sense of wonder and adventure that I felt when looking in that book, albeit tempered by the lusts and losses of adulthood.

For me, the images I create and the stories I write to accompany them, are my own interpretations of the fables and tales I have devoured throughout my life, from *The Little Matchstick Girl* to the *Epic of Gilgamesh*.

My created worlds are inhabited by the same archetypal characters that writers like the Brothers Grimm and Joseph Campbell have illuminated. For centuries, they have served to describe the human experience, at once profane, tragicomical and dogged by existential dread. My heroes and heroines go about their often futile tasks in an analogy of our modern lives; they too are mired in tedium and mendacity, symbolically mocking our own real world endeavours, but acting with an enviable perseverance. My work offers the viewer an implicit invitation to experience nothing less than wonder, awe or a vaudevillian transcendence beyond the tedium of daily life. And it would be nice if they got a little bruised on the way.

The nature of my work, though primarily photographic, is heavily composed and digitally manipulated. I work with analogue and digital cameras. By using various software applications, I composite my subjects into worlds that are almost purely synthetic, being composed of multiple photographs and digital renderings. This method of working, of art existing in the ether of binary numbers, is complementary to the ephemeral nature of the images themselves. I find it almost enchanting that my work exists in a state of quivering potential, swirling somewhere in a sparkling electric reservoir, waiting to be brought into the light of day.

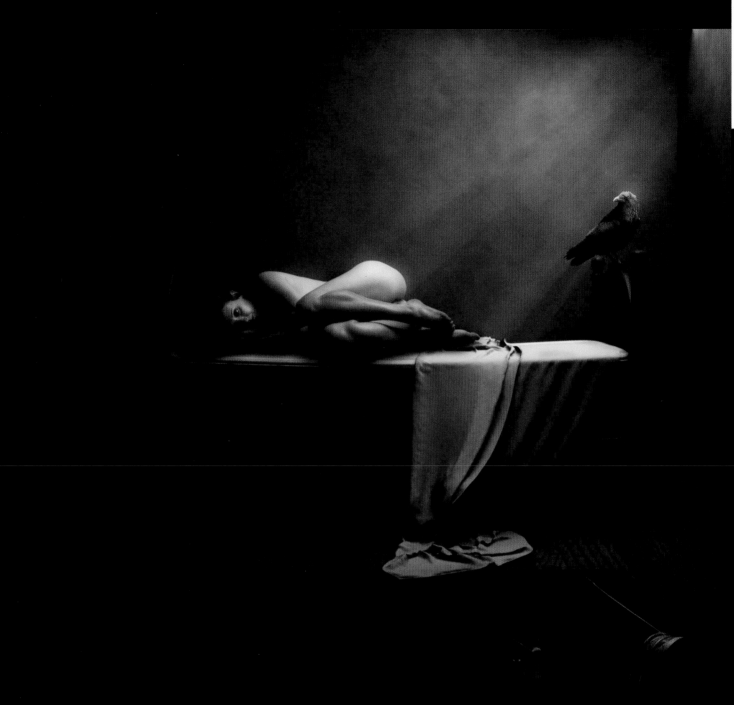

Jamie Baldridge Annunciation

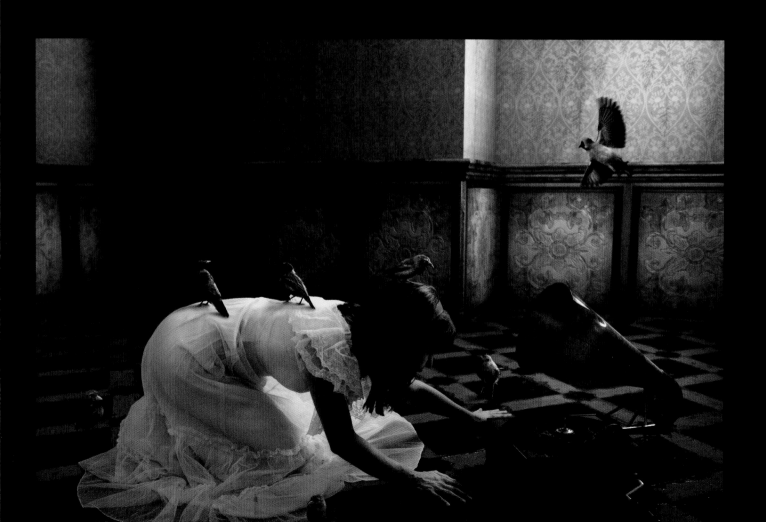

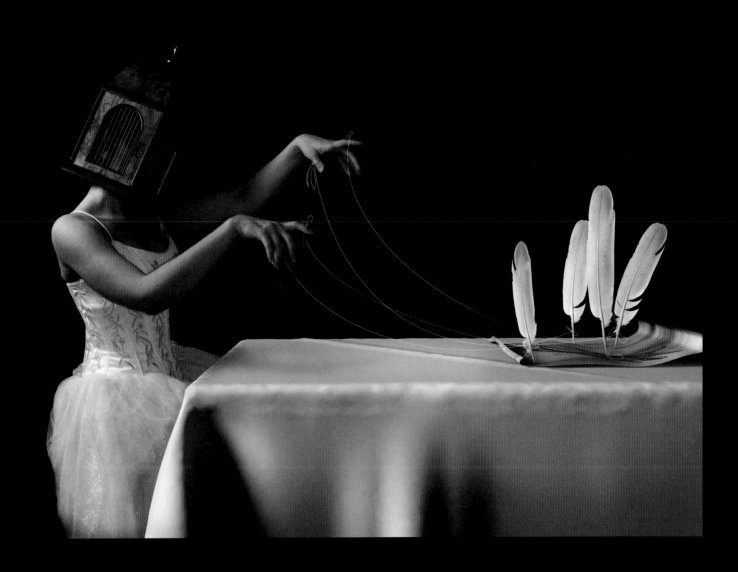

Jamie Baldridge A Ten-Penny Prophet

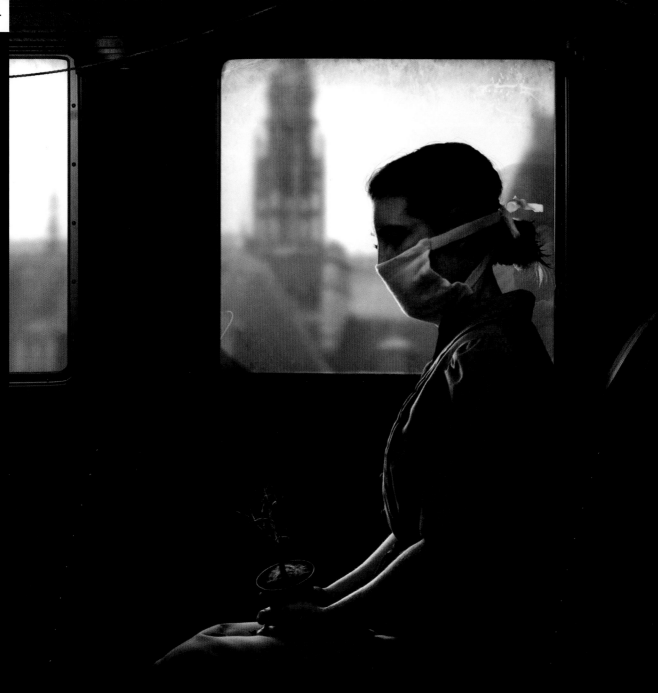

Jamie Baldridge On the train

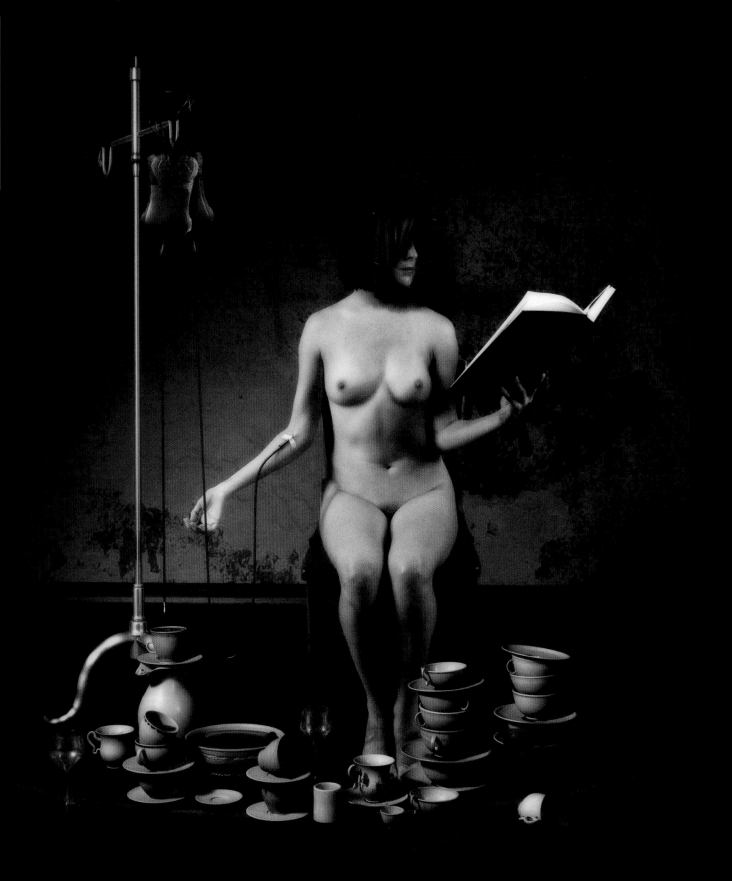

Jamie Baldridge Ellevenses

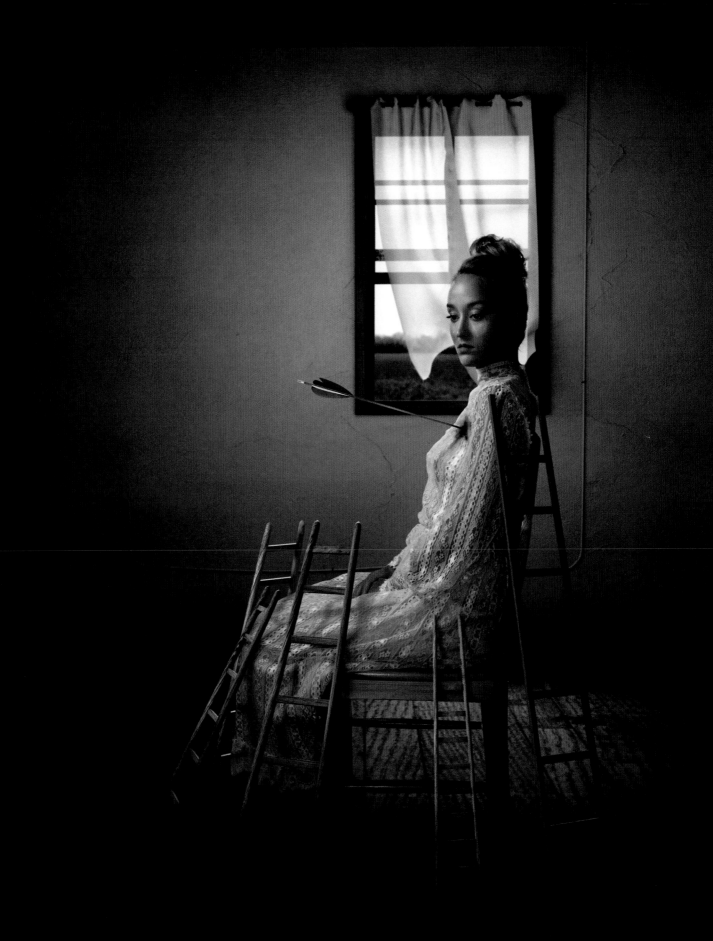

Jamie Baldridge Babylon

photographer

Seb Janiak

http://www.sebjaniak.com

What I try to do with this new work is to find a different way to light.

Coherent light (laser) is interesting as it is simultaneously powerful and subtle. Black and white lights, or shadow and light, bring things to life in our eyes. Without contrast, things would be flat or invisible.

Lighting faces with lasers for beauty is fascinating. It's like painting with light.

All the photography for my personal work is directly created without post-production effects. It is all real.

For me it is more exciting to shoot like that. It offers greater subtlety and I find it more creative as I can play with it on the set. It allows for improvisation, with surprisingly good results!

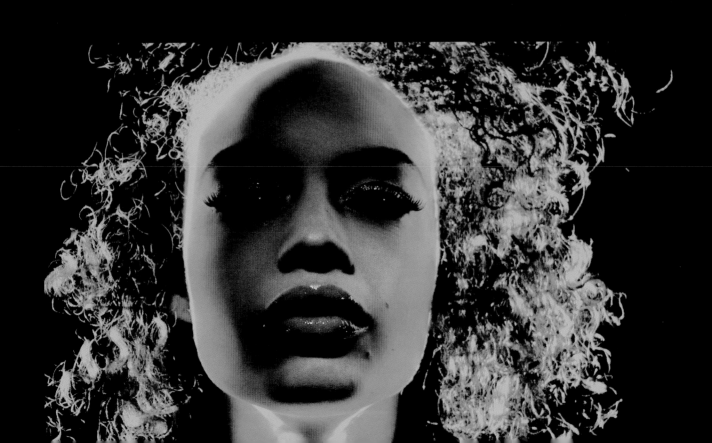

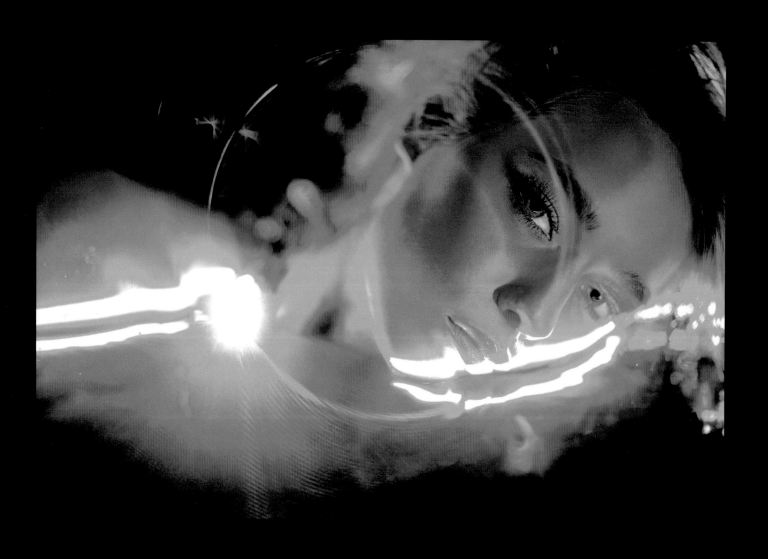

Seb Janiak Disco Sirens 2

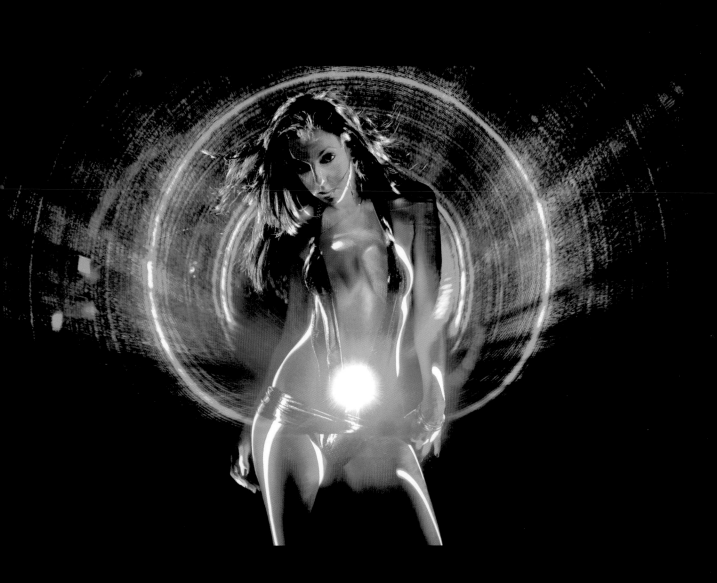

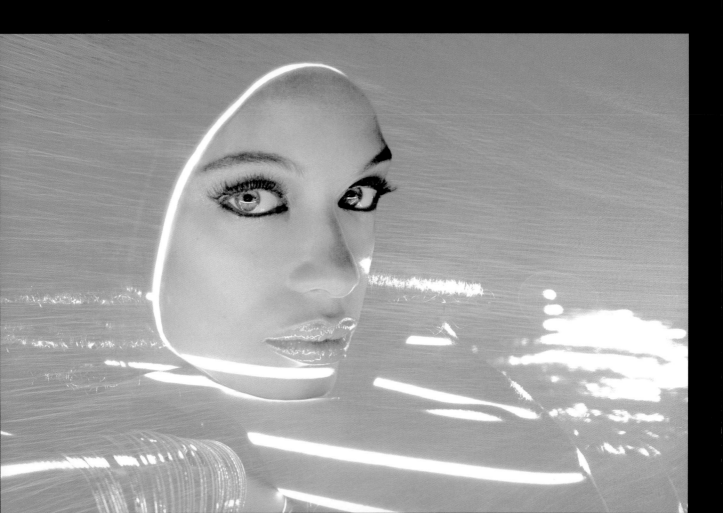

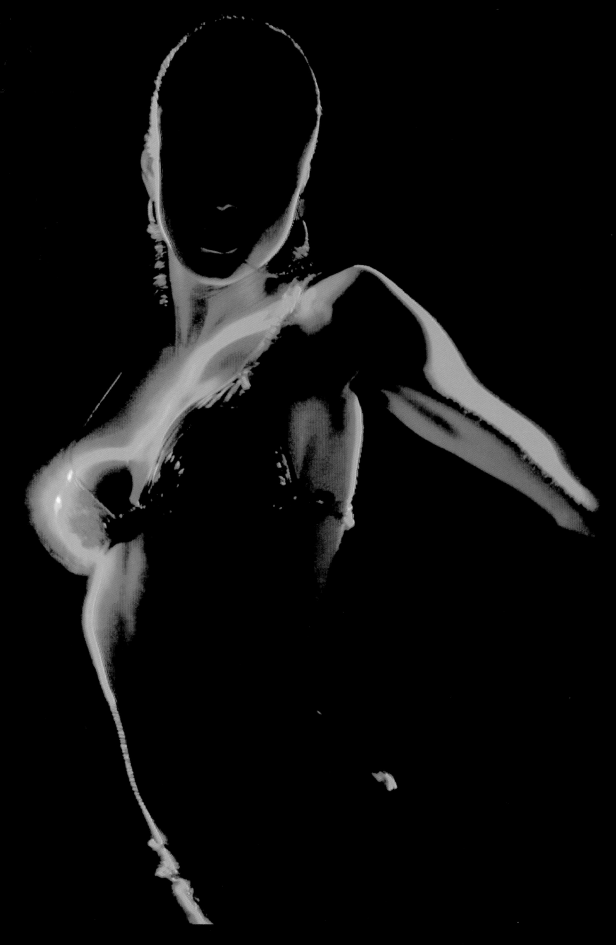

Seb Janiak Disco Sirens 6

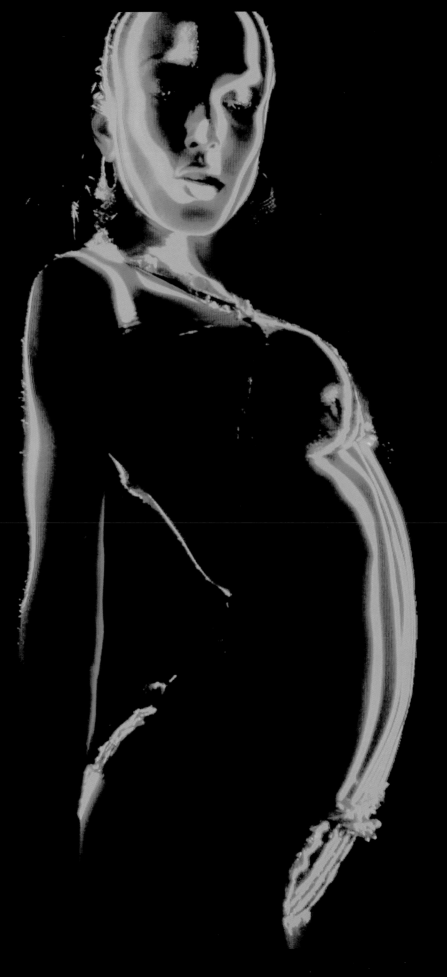

Seb Janiak Disco Sirens 7

photographer

James Chiang

http://www.jameschiang.com

James Chiang is a director/photographer based in San Francisco. He is currently working on two films, both of which examine the compelling duality of perception and reality.

The first is about the male gaze and the second centres on issues of mental health.

120

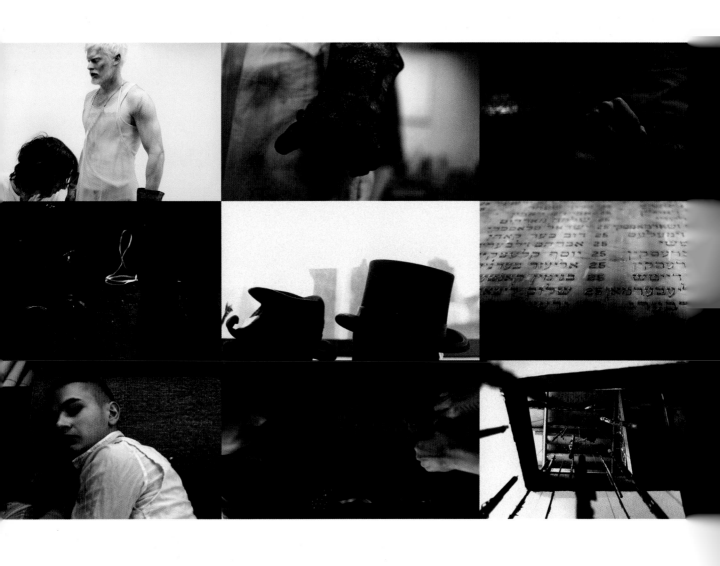

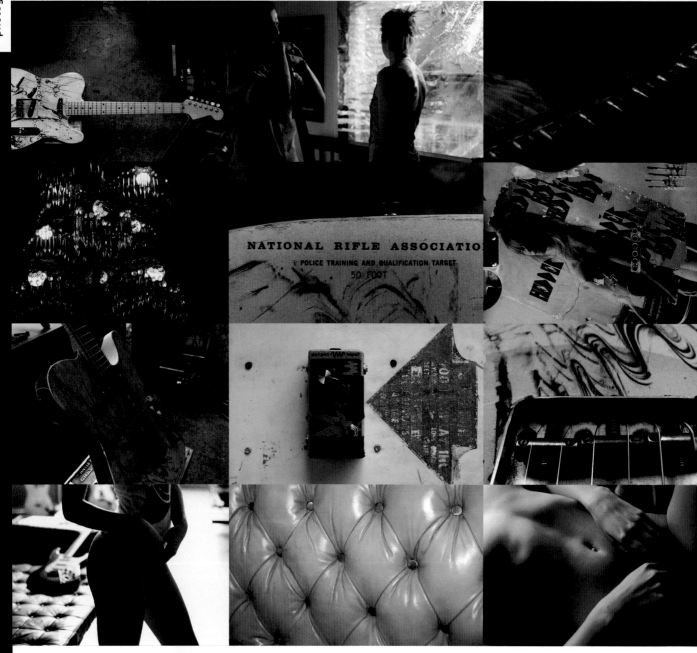

photographer

Carla Verea

http://www.carlaverea.com

When I think of what drives me to create 'Naturaleza Sin-
tetizada', innumerable concepts pop into my head: memory;
computer; camera; analogue vs. digital photography; storage;
a malfunction that becomes a virtue; cyberspace as an infi-
nite playground; layers; textures; funky colours; embracing
the unexpected; accidents; movement; velocity; dimension;
nature; macro; micro; reality; dreamlike; unknown-known;
recognition; variety; variables; fragility; deconstruction; sur-
prise; magic; infinity; instant; freedom; fugacity; Paul Virilio's
words on velocity; Walter Benjamin's concept of the vanished
aura in the age of preproduction; virtual realities; fantasizing
about hidden images within one landscape shot; beauty.....

'Naturaleza Sintetizada' is an analogy of recollection. One
thing is to live in the present; another is when you recon-
struct it in your mind and memory. When you think back,
there will always be interference, an extra layer, a trace of
time, that will never let you see or remember something ex-
actly as it was.

Carla Verea Naturaleza Sintetizada 2

Carla Verea Naturaleza Sintetizada 3

Carla Verea Naturaleza Sintetizada 4

Carla Verea Naturaleza Sintetizada 5

Carla Verea Naturaleza Sintetizada 6

Carla Verea Naturaleza Sintetizada 7

je
we
llery

jewellery designer

Michael Berger

http://www.atelier-berger.de

Michael Berger was born in 1966 in Johannesburg, South Africa, and now lives in Düsseldorf, Germany. From 1987 to 1990 he was trained as a goldsmith in Münster, Germany, and obtained the title of Master Craftsman in 1998.

He has been working professionally since 1990. From 1992 to 1999 he was a staff member and workshop supervisor for Professor Friedrich Becker, Düsseldorf. In 1999 he started his own studio in Düsseldorf-Oberkassel.

Michael won the following awards: Jewellery Prize North Rhine-Westfalia 2004, Bochum Design Prize 2005 and the Tahitian Pearl Trophy 2007/2008 in the category 'Jewellery for Men.'

'While working for Friedrich Becker – the inventor of kinetic jewellery – I became obsessed with the world of kinetics. His work was inspiring and showed me the way to develop my own design, based on his technology and accuracy, combined with my own use of form.

'It always makes me smile when people are simultaneously attracted and irritated when they see my rings for the first time; men usually by the technical work and women by their playfulness and great appeal'.

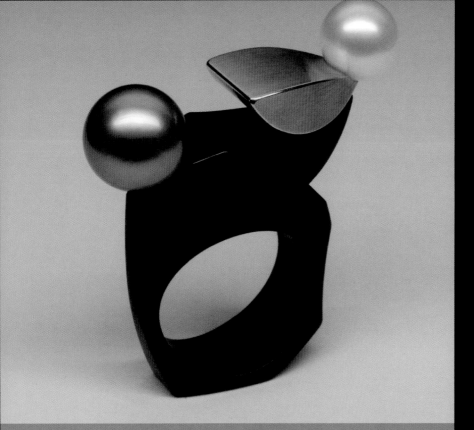

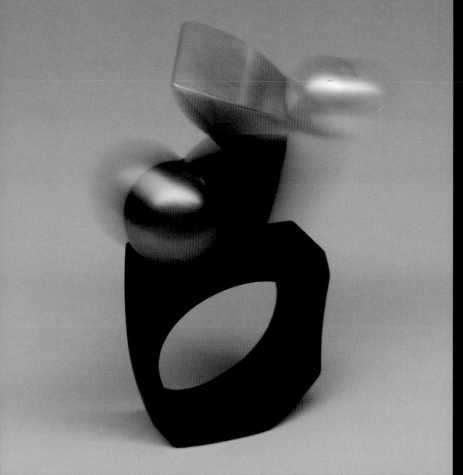

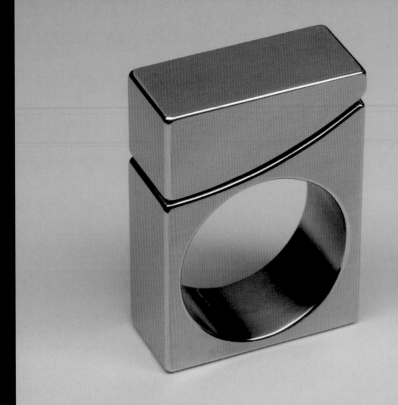

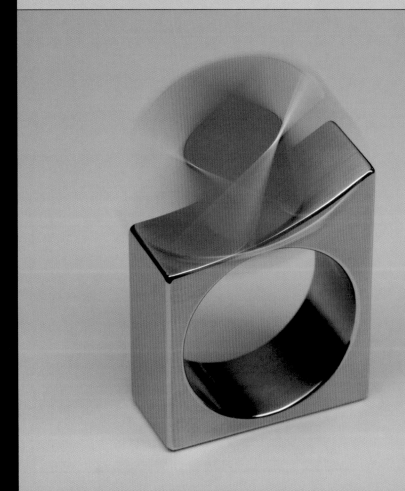

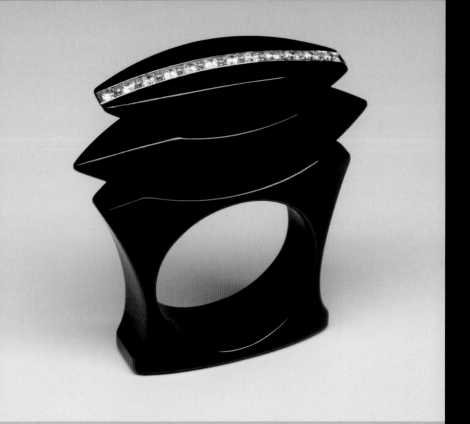

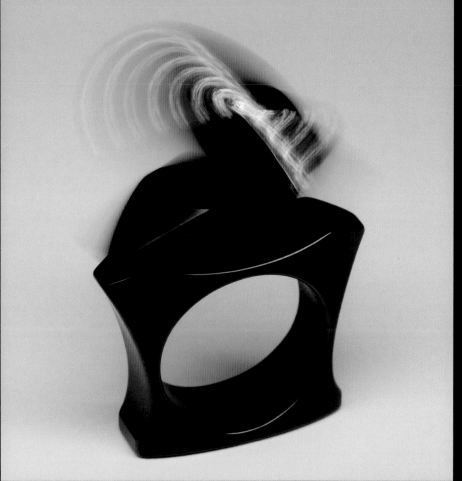

jewellery designer

Andrea Wagner

http://www.andreawagner.nl

On pages 143–145 are pieces from series 'The Architect Who Faced His *Jardin Interieur.*' *Jardin Interieur* is French for 'internal garden' – the private landscape in our mind where imagination has unlimited space and wild overgrowth is allowed, but where rigorous trimming is good too.

A decade of far too many house moves ended my obsession for finding my own permanent place several years ago. And as a foreign migrant, it also terminated my search for *Heimat*, German for home or place of belonging.

This series of work reflects the tension between *Heimat*, a nomadic existence and the need to merge with one's surroundings. An echo of my travels – leaving the safety of the familiar, returning and looking at one's *Heimat* with fresh eyes – informs the series. My pieces have an emotional link with a safe and intimate space away from chaos. The way I use different materials in my work is an essential part in its narrative.

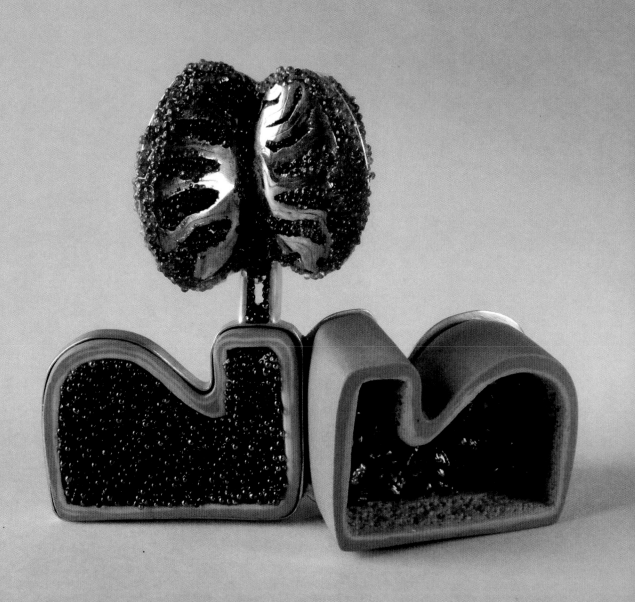

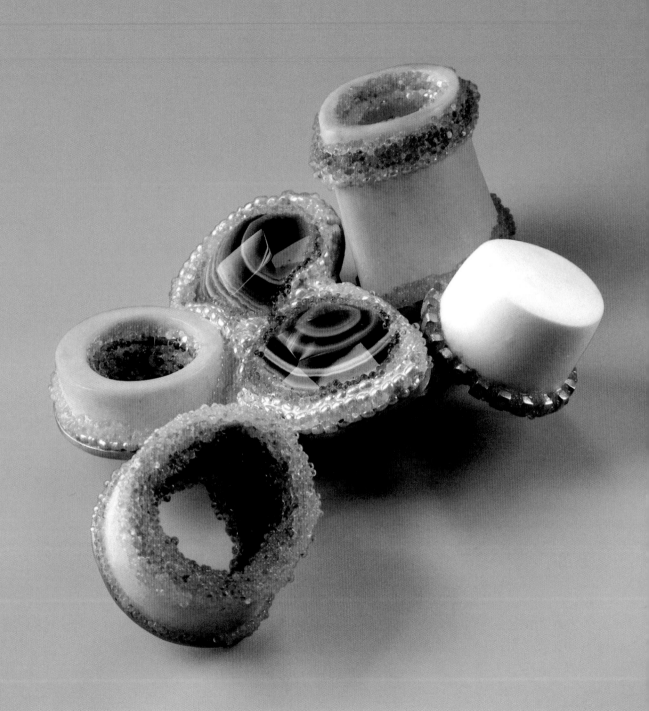

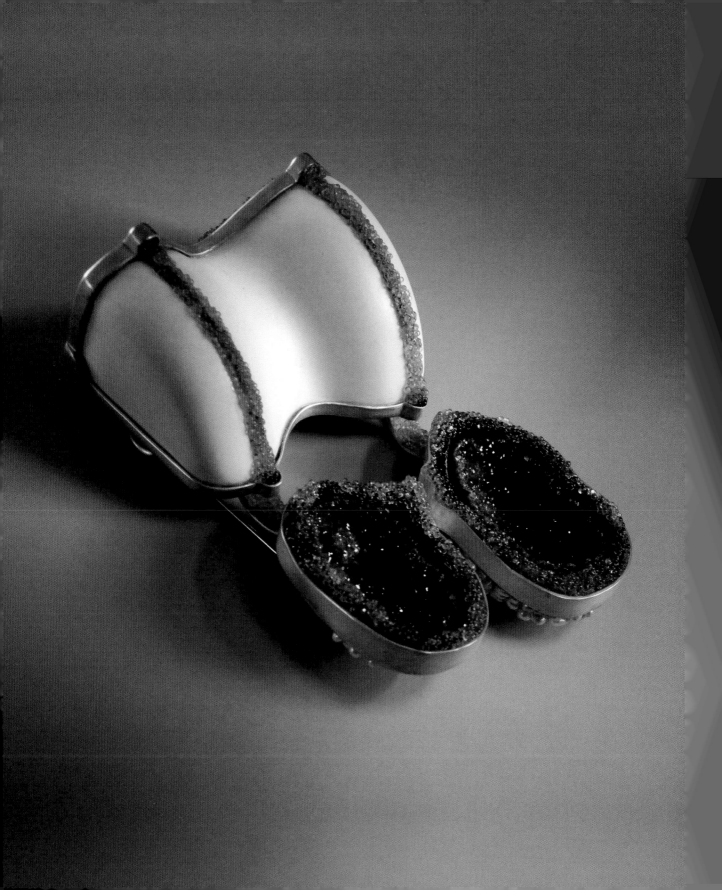

jewellery designer

Marc Monzó

http://www.marcmonzo.net

'For me, the craft of making jewellery provides a base. It represents a starting point for me to deal with things, organise them and make a ritual out of what is taking place. The big project is the attempt to understand through the making. Pieces appear according to my most immediate needs, turning the manipulated matter into a map of my reality.'

Place a rock on a pedestal and it turns into a sculpture. Marc Monzó's jewellery plays to the same effect: a deliberately added, plainly visible pin enhances the status of an ostensibly insignificant piece of plastic. The pin consolidates the shape of the object, while the irregularities and roughness of the material become valuable additions. One's attention is caught and initial rejection turns into desire.

Spain is a country with two faces: on the one hand, warm-blooded and passionate; on the other, reserved and austere. These contrasting qualities can also be found in Spanish jewellery. It is either figurative and colourful or modest and intellectual. Marc Monzó's pieces belong to the latter category. His interventions are subtle, its shapes are clear and the work is modest in size.

He is not concerned with representations of his world, but rather shows us everyday reality in a surprising way.

Monzó often plays with our expectations. He confuses our ideas about value and worthlessness and about the nature of the elements he uses. Things are seldom what they appear to be; in nearly all the pieces, materials have been transformed into something else. The plastic objects mentioned above are given a layer of silver through electroforming; silver parts, by contrast, are finished with lacquer. Monzó's most recent work – 'The silver and gold collection (work in progress)' – refers to classical jewellery, but the silver has been given a coat of silver paint, while the gold is painted gold!

In each of Marc Monzó's pieces, expectations clash with experience; what you know does not match what you see. The result is a sort of a work-out for the mind.

– Ward Schrijver

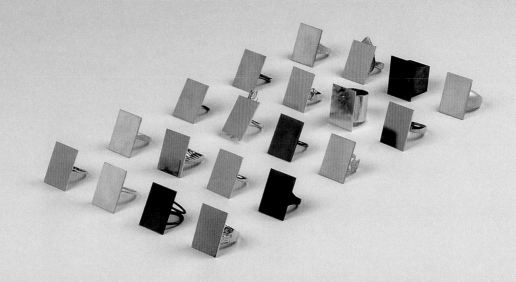

jewellery designer

Mi-Mi Moscow

http://www.mi-mi.ru

Give me The Sound of Happiness!
Give me The Colour of Joy!
Give me The Taste of Wholeness!
Surprise me, show me what I have not seen, have not heard, have not tasted.
Give me what doesn't kill but purifies and raises me from ashes.
If the label on a box says 'Freedom', and inside are found screws...
If with the sound of Jericho's horns murderers are marching...
Show me your Heroes who are miserable under the shadow of golden Idols.
Tell me about The Eternal — not in the howl of wolves but in the whisper of angels
In the Roar of The Crowd of Free People — to hear a lonely voice of The Once Liberated.

Mi-Mi Moscow attempts to contribute with an abundance of surprise and satisfaction. Mi-Mi Moscow is a way of balance between truth and imagination. Mi-Mi Moscow is a biosphere formed by Mila Kalnitskaya and Micha Maslennikov, a Russian tandem that conceives pieces of art in the field of jewellery. They see contemporary jewellery as the victory of style in art. Mila and Micha want to open a door to a room that no one has entered before. And they don't hesitate.

For them the Language of Vibrations is stronger than the Language of Words. This is because an artefact generates a space around it that influences our lives. Its power never disappears but remains latent.

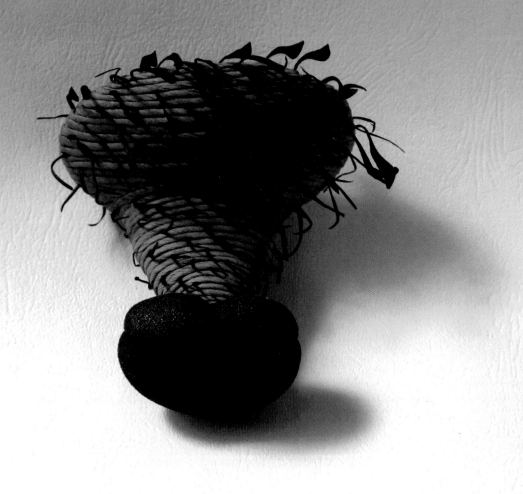

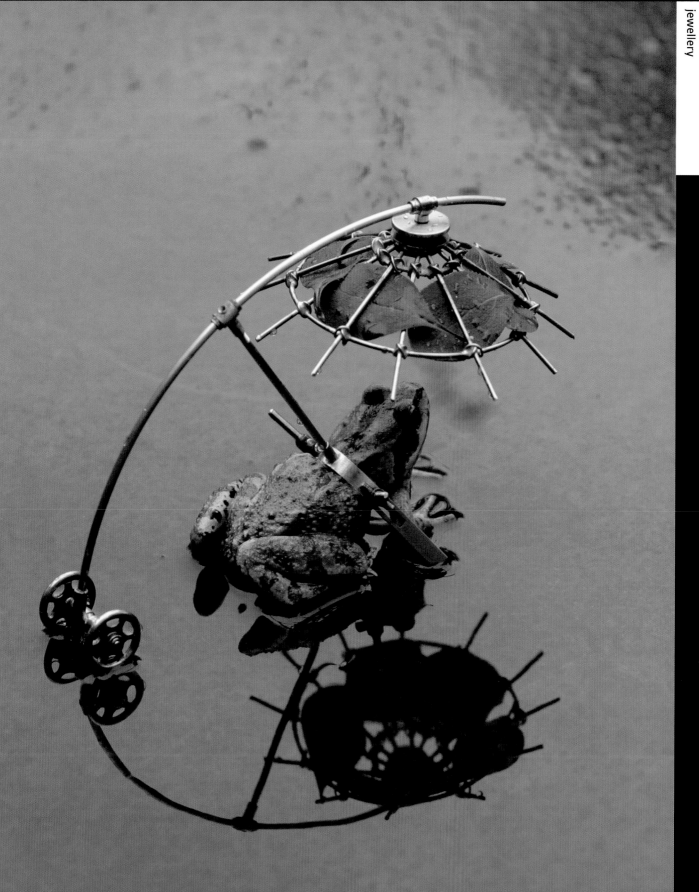

jewellery designer

Carolina Vallejo

http://www.carolinavallejo.dk

In my works, I seek universal questions that are personal to all of us. I choose form and material according to the idea I want to communicate.

I always start with my own questions. Why do we humans behave as we do? What do we have in common and what makes us unique? Where do love and hate come from? What is the soul? What is time and what is eternity? What are the values in life? How do we become happy?

I've asked these questions since I was a child, seeking answers, trying to approach an understanding of life and praying for the world to be better for all of us. We tend to forget real values, while consumerism swallows our lives. Some of the small objects I make are to remind us of what is meaningful: to value time, love and the smaller joys of life.

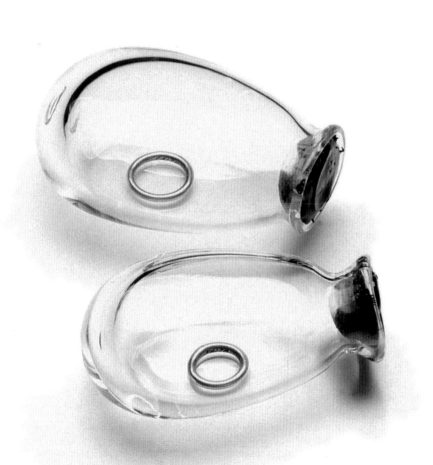

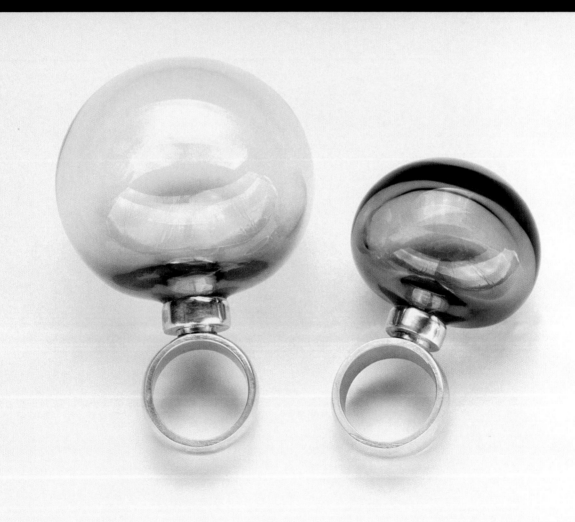

jewellery designer

Jun Konishi

http://www.junkonishi.com

Jun Konishi was born in 1974 in Gunma, Japan. From 1992 to 1997 he studied at the Hiko Mizuno College of Jewellery, Tokyo, with Prof. Kazuhiro Ito. From 2001 to 2007 he studied at the Akademie der Bildenden Künste, München, with Prof. Otto Künzli, where he achieved the status of Master Craftsman in 2005 and obtained his final diploma in 2007, as well as the DAAD prize for foreign students.

In 2000 he had a solo exhibition at the Isogaya Gallery in Tokyo and his work can be found in private and public collections in Germany and the Netherlands.

'More than fifteen years have passed since I presented my work for the first time. And still I am wondering: What is contemporary jewellery? But I will continue to search for answers, with the principle of 'relationship with the body' at the core of my thinking.'

– Jun Konishi

Jun Konishi Brooch study mixed media

jewellery designer

Philip Carrizzi

http://www.carrizzi.com

Every shiny surface reflects an untamed lust for finger, breath, crease, lip, bottle. Wading into McLuhan's tetrad, cupping an overfed breast, watching for the past to swirl away.

Each node probes, fights, is overcome, divides, and is diluted. At a distance, shape seems a smooth and stable boundary (holding colour and texture in repose). Each body suckles, seeds, laughs, fears, bleeds, is worshipped, corrupted and forgotten.

Plunging in, matter is orifice – flesh, a soft and staining buttress for a limp craftsman. I am reading, forming, twisting, smashing, and losing hold of common, unconscious forms; finding that the order I've been nearing is an unshapeable swarm of lust.

These things mark a slippery interface between the pregnant and the obese, the humane and the monstrous, the untouched and the anesthetized.

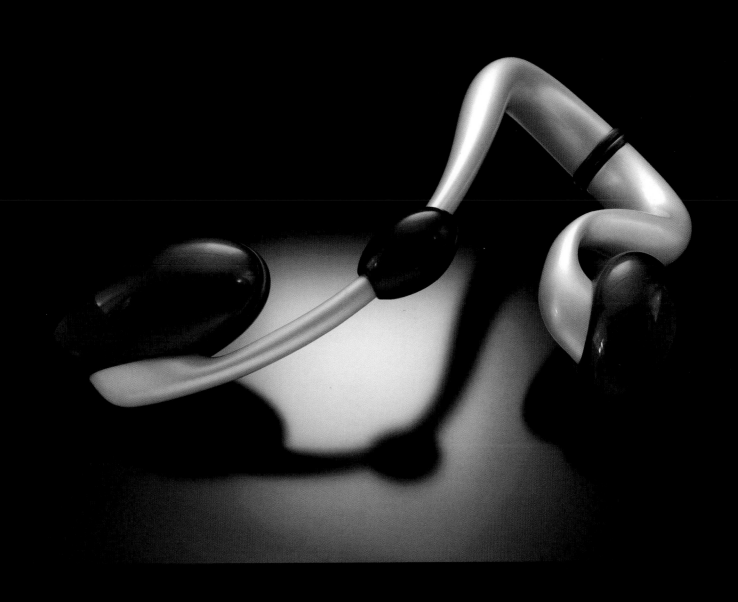

Philip Carrizzi Diploid neckpiece, painted thermopolymer

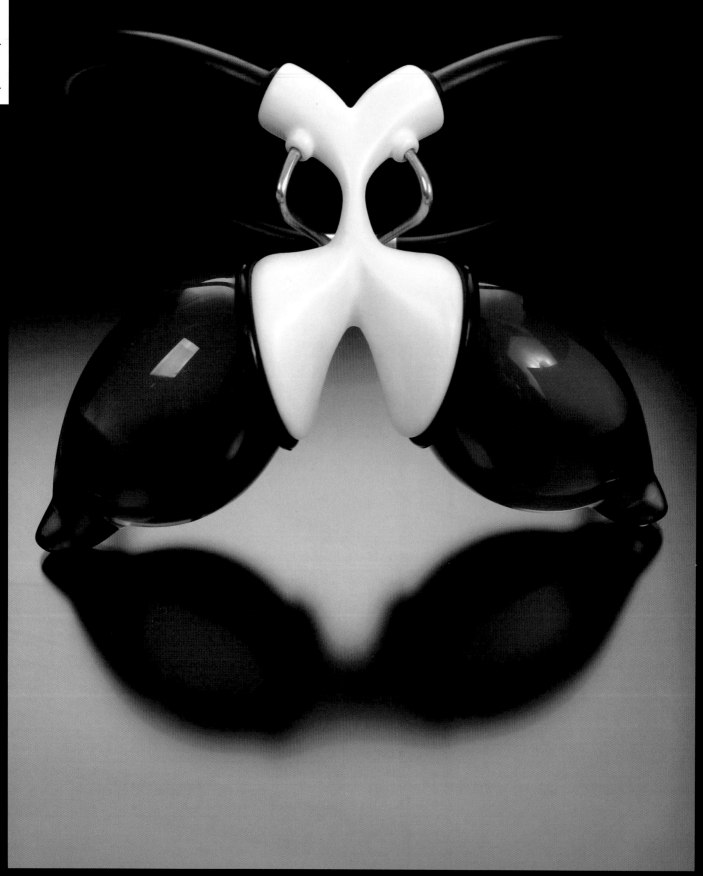

Philip Carrizzi Grammar Pendant, powder coated aluminum and cast urethane and silver

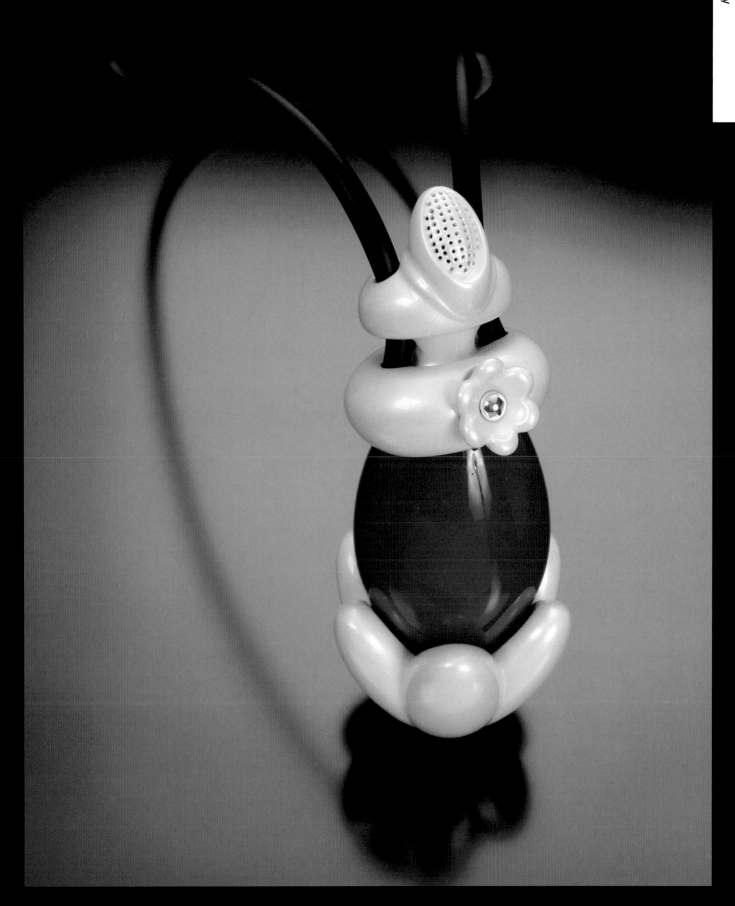

Philip Carrizzi Puff pendant, painted photopolymer

tha
nky
ou

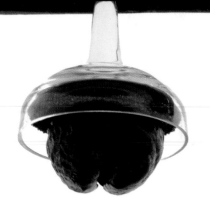

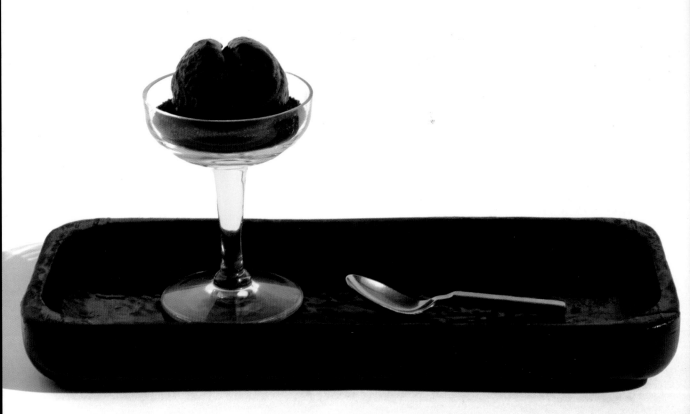